Spirit of the North:
The Art of Eustace Paul Ziegler

by Kesler E. Woodward
with an essay by Estill Curtis Pennington

1998
Morris Communications Corporation in association
with the Anchorage Museum of History and Art
and the Morris Museum of Art

ISBN: 1-890021-05-9 (paperback)

This publication was produced in conjunction with the exhibition, *Spirit of the North: The Art of Eustace Paul Ziegler*, organized by the Anchorage Museum of Art and exhibited there May through September of 1998; exhibited November 1998 through January 1999 at the Morris Museum of Art, Augusta, Georgia; and subsequently at other museum venues.

Cover art: Eustace Ziegler. **Beach Seiners** *oil on canvas, 34 x 40 inches*
 The Alaskan Art Collection of Morris Communications Corporation
 Michael Walmsley, photographer

Design: Todd Beasley and Vincent L. Bertucci
 Lydia Inglett, Director of Creative Services, Morris Communications Corporation

Table of Contents

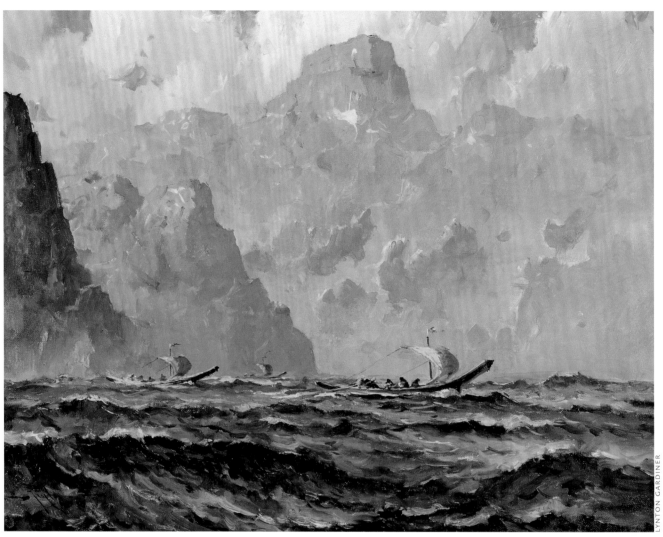

LYNTON GARDINER

Going to Potlatch
Oil on canvas, 21 x 27 inches

Spirit of the North: The Art of Eustace Paul Ziegler has been from start to finish a collaborative effort of the Anchorage Museum of History and Art, in Anchorage, Alaska, and the Morris Museum of Art in Augusta, Georgia. It was born in the vision of leaders of both institutions— William Morris III, Chairman of the Board of the Morris Museum, and Patricia Wolf, Director of the Anchorage Museum. This exhibition and publication grew out of their vision, commitment of resources, experience, and insight.

The staff members of both museums also deserve tremendous thanks for their roles in bringing the exhibition and catalogue to life. In addition to Director Pat Wolf, Walter Van Horn, Curator of Collections; Diane Brenner, Archivist; Barbara Geib, Registrar; and Walt Hays, Development Director of the Anchorage Museum have been involved continuously in the project from its outset. Dave Nicholls, Curator of Exhibits and Sharon Abbott, Curator of Education at the Anchorage Museum helped define the shape of the opening exhibition and produced the interpretive materials which travel with it. Morris Communications Corporation took on the major task of producing this publication, both financially and logistically. Thanks go to Lydia Inglett, Director of Creative Services, and to Designers Todd Beasley and Vincent Bertucci. At the Morris Museum, in addition to Director Louise Keith Claussen, who coordinated the catalogue production, thanks are due to Catherine Wahl, Registrar; and Cary Wilkins, Librarian and Archivist.

Special thanks are also due to Estill Curtis Pennington, the Morris Curator of Southern Painting, for his fine essay included here, "The Seekers and the Sought: Notes on the Pictures of Eustace Paul Ziegler." Pennington's extensive knowledge of and curatorial experience with both Southern painting and Alaskan pictures provides the basis for his probing insight into the work of Ziegler and its relationship to that of other regionally and nationally prominent American artists.

Both in making the selections for the exhibition and in the writing of my own essay, I have had the generous contributions of many people. My research assistant Phyllis Movius did an extraordinary job of background research on Ziegler, uncovering many previously unknown documents, helping organize the wealth of information with which I worked, and serving as manuscript editor for the text itself.

Len and Jo Braarud of La Conner, Washngton, were unstinting in their help with all aspects of the project. Their gracious help contacting and visiting owners of Ziegler paintings in the Seattle area and elsewhere, their willingness to share information, and their genuine love of Ziegler's work were essential to the success of the project, and as always a delight. Joe Crusey and Army Kirschbaum of Anchorage provided important help with collectors and collections in the Anchorage area, and Candy Waugaman of Fairbanks unselfishly shared key information and resources from her own collections and her deep knowledge of Alaska history.

I am especially grateful to H. Willard Nagley II, who provided major financial support, as he has to so many of my projects and others at this and other museums in Alaska. Among many other financial contributors, Alaska National Insurance Company, the Stack Foundation, the Hugh and Jane Ferguson Foundation, and Braarud Fine Art were major donors. The entire project is supported by grants from the Alaska State Council on the Arts and the National Endowment for the Arts, a federal agency in Washington, D.C.

Finally, I would like to thank the collectors of Ziegler's work, who have generously chosen to share their collections with a wider public. Ziegler collectors love their paintings, and it is a measure of their generosity that they have reluctantly agreed to part with treasured paintings for an extended period so that others can get a glimpse of the Spirit of the North embodied in Eustace Ziegler's art.

FOREWORD

Although it might seem unusual for a museum concerned with painting in the South to be involved with an exhibition of works by a painter of Alaska and the pacific northwest, there is, indeed, a connection. My own interest in the art of Alaska came about through our newspaper company's purchase of the daily newspaper, the Juneau Empire, in 1968. With the construction of a new building for the Juneau newspaper in 1985, my wife, Sissie, and I began assembling a collection of Alaskan art works to be housed there.

Among the Alaskan "old masters" included in that early collection was Eustace Ziegler. Since that time, the Alaskan collection has grown and matured, and we have acquired several significant works by Ziegler, an important artist whose work captures so well the frontier he experienced first hand, the grandeur of the vast landscape he explored, and the lives of the people he knew well.

The Morris Museum of Art, located in Augusta, Georgia, hosted an exhibition of works from the Juneau Empire Collection in the winter of 1996, bringing the beauty of Alaskan images to a new audience in the southeastern United States. We are now proud to be collaborating with Pat Wolf, Director, and the Anchorage Museum staff, in bringing the work of Eustace Ziegler to a broader audience. Kesler Woodward, art professor, artist, essayist for this catalogue, and curator of the exhibition, has explored many new avenues and uncovered works never before shown in a museum exhibition. And with this publication, Morris Curator of Southern Painting Estill Curtis Pennington offers additional insight into Ziegler's work.

The art of Eustace Ziegler certainly has appeal beyond Alaska and the Northwest. Along with his depictions of a rugged and spectacular land, his sensitive portrayals of people — the miners and timbermen, the hardy seafarers, and the mothers with their children — reflect the artist's appreciation for the way they lived their lives. We are pleased to have a role in presenting to a wider audience new aspects of the painter Eustace Ziegler and the scope of his career as an artist.

William S. Morris III

Chairman and CEO, Morris Communications Corporation
Chairman of the Board of Trustees, Morris Museum of Art

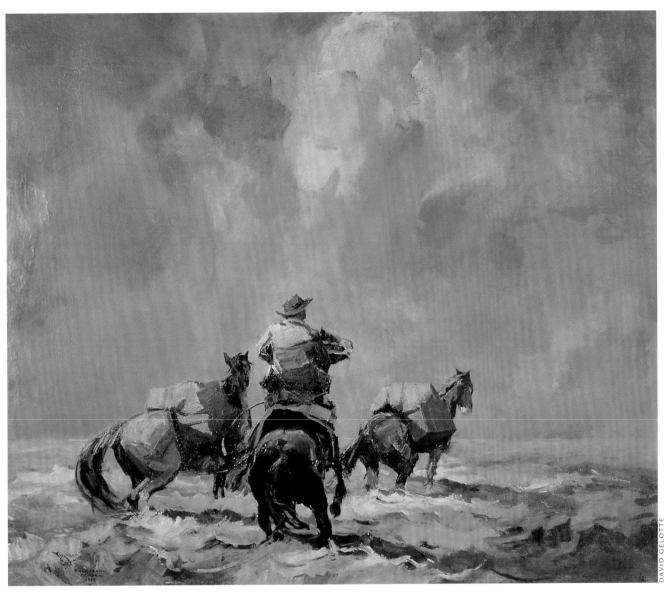

The Fording
Oil on canvas, 34 x 40 inches

DIRECTOR'S FOREWORD

The Anchorage Museum of History and Art is proud to be the co-sponsor with the Morris Museum of Art of the exhibition, "Spirit of the North: The Art of Eustace Paul Ziegler." While casual visitors may wonder about this partnership, those with more in-depth knowledge of the two museums will recognize the commonality of interests in Alaskan art and Alaskan artists found in both institutions. As director of the Anchorage Museum, I wish to acknowledge the generosity and continuing interest of William S. Morris III in this project. Morris, the founder of the Morris Museum of Art, is a patron of the arts and an ardent collector of both Southern and Alaskan art. While the Anchorage Museum specializes in art of the North and the Morris Museum focuses on art of the South, the uniting factors are the private and corporate collections of William S. Morris III, who collects art of both regions and is generous in sharing his collection with the interested public. We value our ongoing relationship with the Morris Museum, and would like especially to acknowledge Estill Curtis Pennington for contributing an essay for the catalogue and Louise Keith Claussen for her work in publishing the catalogue.

Both museums are indebted to guest curator Kesler Woodward who selected the works of art to be included in the exhibition and wrote the major essay for this catalogue. Although Woodward works primarily as a professor of art at the University of Alaska, Fairbanks, and as an artist, he is not a new figure in either museum. For the Morris Museum, he was a guest lecturer for the 1996 exhibition, "Frontier Sublime: Alaskan Art from the Juneau Empire Collection," and his work was included in the exhibition. He curated the exhibit "Sydney Laurence: Painter of the North" for the Anchorage Museum in 1990 and wrote the exhibition catalogue, published by University of Washington Press. In 1993 he wrote, *Art of the Far North,* a catalogue of the Anchorage Museum's permanent collection which was published in celebration of the Museum's twenty-fifth anniversary.

An exhibition of this magnitude requires borrowing many significant works of art. We gratefully acknowledge the many lenders to the exhibition. I would especially like to thank Ann Ziegler Cahan, Richard and Irene Cook, the University of Alaska Museum, the University of Washington, Morris Communications Corporation, the Heritage Library of the National Bank of Alaska, and the Skinner Corporation for their generosity. In addition, special recognition is due to Len and Jo Braarud of La Conner, Washington, for their support of the exhibition and willingness to share information about the artist. They have been good friends of the Anchorage Museum for many years, and we value their support.

As anyone who has organized an exhibition of this magnitude is aware, a successful exhibit requires an outstanding curator and writer, generous lenders and substantial financial support. Initial major support for the exhibition has been provided by H. Willard Nagley II, George Suddock and the Alaska National Insurance Company, the Stack Foundation, the Hugh & Jane Ferguson Foundation, the Herb and Miriam Hilscher Memorial Fund, and the Anchorage Museum Foundation through the Kreielsheimer Fund.

Finally, I would like to acknowledge the support of the Anchorage Museum staff. Dave Nicholls, the Curator of Exhibits, and the Assistant Curator of Exhibits, Allan Shayer are responsible for the exhibition design and installation. Barbara Geib, former Registrar, and Janelle Matz, Assistant Curator of Collections, have assumed the duties of loans, shipping and conditioning the objects. Sharon Abbott, Curator of Education, has worked on education programs, docent tours and publicity, and Diane Brenner, Museum Archivist, was in charge of photography and organizational details of the exhibition preparation. I am sure that you will be as pleased as I am with the results of their hard work.

Patricia B. Wolf
Director, Anchorage Museum of History and Art

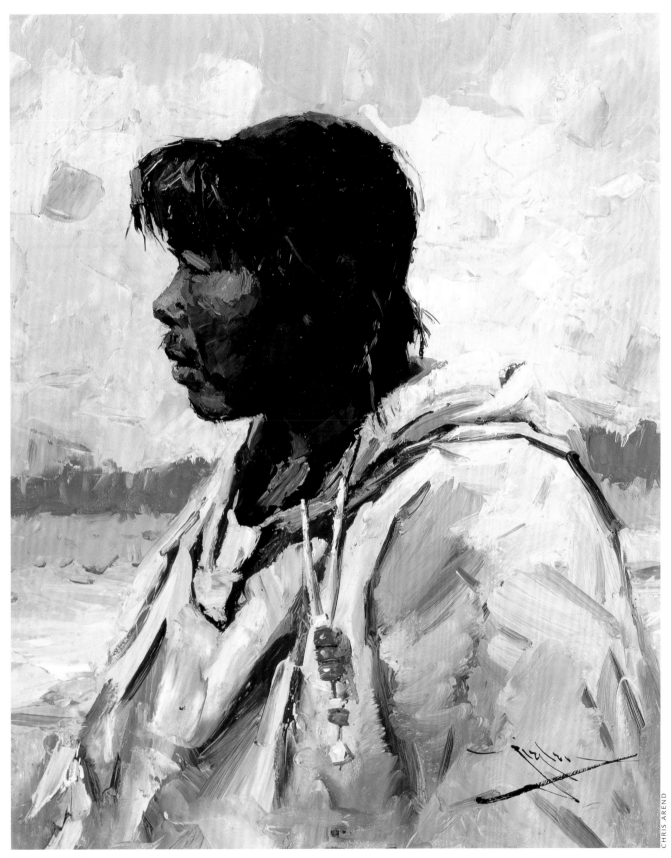

Untitled-Eskimo man
Oil on canvas, 20 x 16 inches

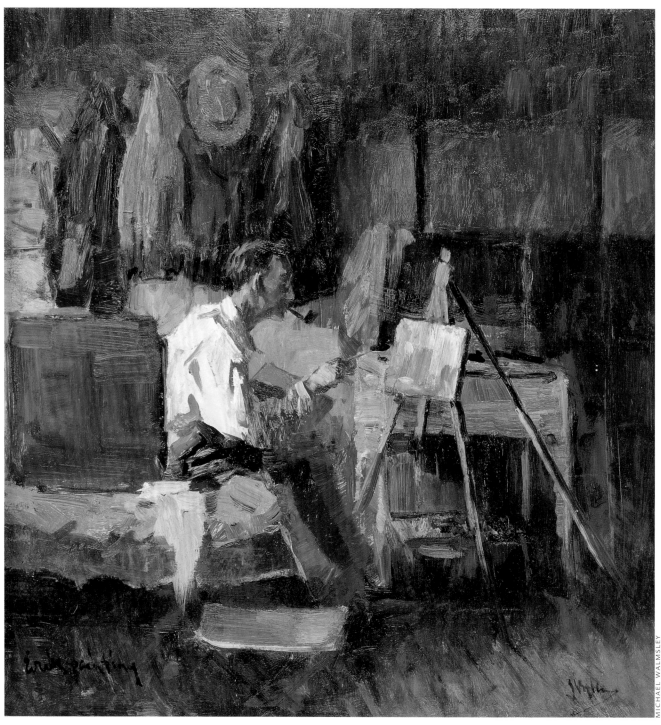

Erik Painting, 1933
Oil on canvasboard, 20 x 19 ¹/₂ inches

MICHAEL WALMSLEY

"Eustace Ziegler in Talkeetna, about 1940, where he went to paint."

Spirit of the North: The Art of Eustace Paul Ziegler

Better than any other artist, Eustace Paul Ziegler (1881-1969) captured the spirit of the early twentieth century Alaskan frontier. Arriving in Cordova, Alaska, in January of 1909 to operate the Red Dragon, an Episcopal mission in the mining boom town, the young lay missionary quickly became known for his paintings of the people on the northern frontier—Native Alaskans, priests, miners, trappers, fishermen, and others living the rough but thrilling life of the still-new Territory.

Though the son of an Episcopal minister in Detroit and destined, like his three brothers, to be ordained to the clergy, Eustace Ziegler was attracted to art from an early age. Trained in painting at the Detroit Museum of Art and in the life of the woods in Michigan lumber camps, he came to Alaska in 1909 well-equipped to live the pioneer life, to minister to spiritual and earthly needs, and to capture on paper and canvas the exciting character of the fast-changing frontier life of the North.

For the next fifteen years Ziegler was an integral part of that life. With short breaks for training in both the ministry and in art, he not only ran the Red Dragon and later served as priest of St. George's church in Cordova, but he traveled by pack train, dogsled, snowshoe, and boat in all

seasons to the mining communities of the Copper River country. In the process he served his church and the people of his far-flung diocese, and he accumulated many of the experiences, stories, and visual images which he would draw upon in his paintings for decades after. This publication, and the exhibition it accompanies, are intended to examine in some detail the rich fabric of those Alaskan years, showing the way Ziegler's work as an artist became interwoven with his work as a priest.

When the 44-year-old artist was given the chance to complete a series of large-scale murals for the Alaska Steamship Company offices in Seattle in 1923, he and his wife Mary jumped at the opportunity. Though they returned to Cordova after completion of the murals, in 1924

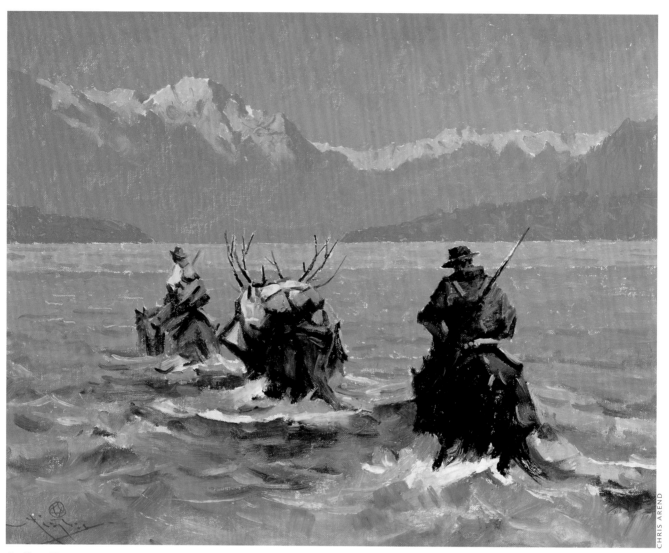

Caribou Hunters
Oil on board, 16 x 20 inches

the artist and his family moved permanently to Seattle, and he abandoned his ministry to pursue his art. Why did he choose to leave the ministry and Cordova? This account is intended to take a new look at the combination of factors that influenced that decision.

Ziegler would soon become a well-known and influential figure in the Seattle art scene and would remain so until his death in 1969. He was a founding member and first president of the Puget Sound Group of Northwest Painters and a frequent exhibitor and prize winner in Seattle's annual Northwest Artists Exhibitions. A prominent contemporary Seattle artist called him, "the unquestioned master of local pictorialism," and "a key figure in bringing to the Northwest a real

sense of sophistication in use of paint, being rather a parallel to [Mark] Tobey in that they both introduced us to high standards of craft, one as traditionalist, one as iconoclast."[1]

But "Zieg," as he was called by all who knew him, returned to Alaska nearly every summer to paint, and the majority of his work throughout his career, including that done in his studio in Seattle, depicted life on the northern frontier. Why did his focus remain on Alaska? Why is he known even today as an Alaskan painter, when he spent at most only fifteen years as a resident of the Territory and almost exactly three times that many years in Seattle? The answers to those questions have become clearer in the course of preparing this exhibition.

Another question addressed here is the artist's place in the history of Alaskan art. His work is most often compared to that of Sydney Laurence (1865-1940), Alaska's best known historical painter. Their names are invariably the first two uttered in any discussion of Alaskan painting, and each has his adherents as Alaska's greatest historical painter. But though they worked in Alaska for much of the same period, knew each other, and painted many of the same subjects, especially the lofty Mt. McKinley—North America's highest peak—their visions of Alaska were quite different. Examined here are the differing roles they played in defining Alaskan art for future generations.

For Ziegler, the attraction of the North was the men and women who struggled, worked, played, lived, and died there. In contrast to the largely symbolic figures that appear in the work of Laurence and other Alaskan artists of his era, Ziegler's people are individuals—whether young or old, Native or non-Native, miners or hunters, engaged in work or posed for portraits. We seldom are given their names, but they are rarely stereotypes, and each portrait gives us a glimpse into the character of the individual and the quality of life in Alaska in this fascinating era.

Spirit of the North: The Art of Eustace Paul Ziegler draws on extensive collections of the artist's work from Alaska and the Pacific Northwest to Hawaii, California, and New York. It includes approximately one hundred of Ziegler's paintings from throughout his career, a selection of his striking etchings and drypoints, and examples of his rich illustrative work. No extensive publication has heretofore been produced on the artist, though there have been a number of large exhibitions of his work—at the Anchorage Museum, the Frye Art Museum in Seattle, and elsewhere.

The 1977 exhibition organized at the Anchorage Museum by then-director Robert L. Shalkop and the brief but excellent catalogue essay he wrote for that show laid the foundation for serious biographical and art historical research on the artist. This exhibition seeks to fill in the artist's biographical outline and to place his paintings more fully in both historical and artistic context.

The exhibition also seeks to bring before the public for the first time a full array of the artist's work. Ziegler was a very prolific painter,

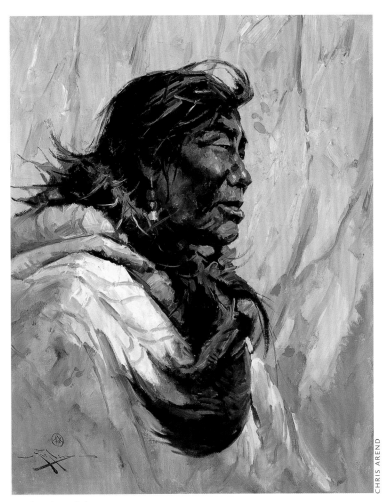

Native (Arctic)
Oil on board, 12 x 10 inches

CHRIS AREND

and estimates of his lifetime production range upward from a minimum of three or four thousand paintings to half again that number. But even in Alaska and the Pacific Northwest, where he is best known, most people are familiar with only a narrow range of his work. Between one and two dozen favorite images, repeated in a variety of scales and mediums from tiny drypoints to wall-sized murals, comprise the bulk of what most people have seen of his paintings.

All but the most serious collectors of Ziegler's work will be surprised by the range and depth of his imagery. He emerges in this exhibition, for example, as the preeminent chronicler of Native Alaskans in the first half of this century. His clear, sympathetic, but unsentimental view of Alaska's Native people as individuals is one of his most important contributions to Alaskan art, and heretofore

perhaps his most under-appreciated. This and other aspects of his work are explored here in detail for the first time.

Eustace Paul Ziegler's view of Alaska was romantic, but grounded in the reality of the life he saw and lived. The Alaskans who people his pictures are celebrated, but not made any more or less heroic than he found them. As we see in his paintings and read in his words, he had few illusions about his fellow creatures, but he came to love the place and the life of which they were all a part. Though he left Alaska in person, he never left it in spirit. As he replied so frequently when asked if he was an ex-sourdough, "I'm a sourdough. There's no such thing as an ex-sourdough!" He also explained, "I keep coming back because I have to. Alaska is part of me. The better part."[2]

This romantic view of Alaska is echoed in one of the best short appraisals of Ziegler's character and work, by Phyllis Carlson, a writer who grew up next door to the artist in Cordova and knew him well. She wrote about his work, "It is a man challenging a Nature he cannot conquer, but by hope and strength can learn to live in. If now and then we lament the passing of those vivid days, we can renew our spirits before Eustace Paul Ziegler's canvases, for he dipped his paint brush into life as it was lived in the rough and rugged days of Alaska's youth."[3]

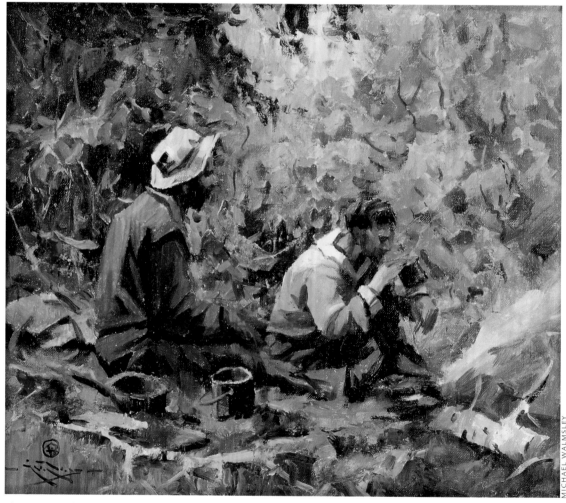

MICHAEL WALMSLEY

The Camp (Zieg and Ted)
Oil on canvas, 12 x 14 inches
Inscribed: "To Fred from Zieg / A very bad picture I could never sell"

Spirit of the North:
The Art of Eustace Paul Ziegler

by Kesler Woodward

The story of Eustace Paul Ziegler's rise to prominence as one of the most beloved painters of Alaska and the Pacific Northwest, begins on the pier at Cordova, Alaska, on a snowy January day in 1909. The 27-year-old lay missionary, a passenger on the steamer S.S. Yucatan, captained by "Dynamite" Johnny O'Brien, was coming to take charge of the Red Dragon, the Episcopal mission house in the very raw new boom town. It is not hard to imagine the mixture of excitement and bewilderment felt by the slight, wiry young man as the little steamer on which he was a passenger gingerly approached the Alaska Steamship Company dock in near-blizzard conditions. It is hard to say which of the sights greeting him there amazed him the most, but it is indicative of his future preoccupations as an artist that it was the people — his fellow passengers and those waiting ashore — rather than the dramatic scenery or the fierce weather that most attracted his attention.

Recalling his fascination with the scene, he would later describe a brightly painted woman passenger carrying a parrot in a cage, another with a monkey on her shoulder, still others clutching pugs, poodles, and cats, and on the dock waiting men in derbies, starched-front shirts and stickpins coming forward to claim them all. "I'd never seen women like that before," he would say years later, "and I'd never spoken to a man like that. It just hit me, then and there, what was going on...."[4]

We will return to this scene, and to the young Ziegler's reactions to it, as they tell us a surprising lot about him as a man, as a future minister, and as an artist. But first we must take a closer look at the combination of factors that brought him to such a place. The knot of circumstances which began the tapestry of

Eustace Ziegler's lifetime fascination with Alaska was tied at the intersection of a number of social, historical, and personal threads. We need to understand those threads, and how they came together, to begin to understand his place in Alaska and his contribution to it.

Eustace Ziegler's arrival in Cordova came about as a result of the combination of three major factors — his own upbringing, a surge in large-scale missionary efforts on the part of American churches in the late 19th century, and the Klondike gold rush and its related mining activity in Alaska. In the absence of any one of these components, Ziegler would probably never have come to Alaska, and he may never have found a way to combine his love of adventure, his love of art, and his calling to the ministry.

Family Values—Religion and Work

Perhaps the most fundamental element leading to Ziegler's arrival in Alaska was his upbringing. He was born in Detroit, Michigan on July 24, 1881, the son of the Reverend Paul and Mary Frances Bell Ziegler. His father was

rector of Mariner's Church in Detroit for 27 years, beginning in 1883,[5] as well as the head of an Episcopal school for boys which was attended by Eustace and his three brothers.[6] Though he would later follow his three brothers into the

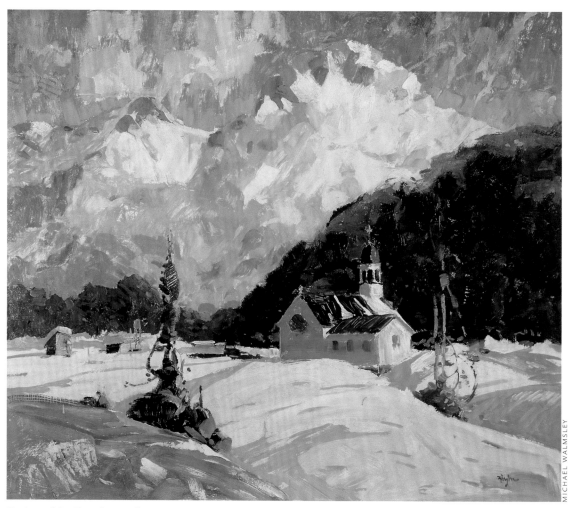

MICHAEL WALMSLEY

St. Joseph's Church, Cordova
Oil on Masonite,® 34 x 39 ¾ inches

Episcopal ministry, he was determined to become an artist as early as the age of seven.[7]

Ziegler's father evidently did not oppose the young man's wishes, even as they continued into his teens. An early article on him in the *American Magazine of Art* reports that his father's one condition in accepting the idea was that Eustace be able to make a living at the work.[8] Whether this onus was laid on him literally or was simply ingrained in his rearing, the fact that he felt it is clear in the choices he made throughout the rest of his life. It was an admonition that the young artist took to heart immediately and never abandoned.

The determination to make a living at his work and to provide for his family would be one of Ziegler's most steadfast and most salient characteristics. In his later years newspaper accounts with titles like "Ziegler, An Artist Who

Eats Regularly,"[9] and "He 'Digs Gold' With a Paintbrush"[10] would focus on his work ethic. Numerous articles detail the "regular office hours" he kept in his downtown Seattle studio.

Though he would develop and maintain a romantic vision of Alaska, he would forever be aggressively unromantic about his calling as an artist. A 1956 *Seattle Post-Intelligencer* article by his longtime friend Fergus Hoffman[11] is one of many that stress the very practical attitude with which Ziegler approached his work. In the curiously alternating self-deprecation and pride that characterizes virtually all of his self-appraisal, Ziegler would insist that his only distinction is that he is an artist who earns his living simply by painting, but he notes with pride that he sells everything he produces, and that he sold at least one small sketch a day even during the Depression.

Such pragmatic pronouncements must have made many among the non-artist public uncomfortable. In his day, as now, much of the public wanted their artists to be almost ethereal creatures, driven by romantic urges and not subject to the same needs and appetites as ordinary folk. Ziegler had little patience with this ultimately marginalizing and unrealistic view of art and artists, and he seemed to delight in puncturing any such pretensions interviewers attempted to foist upon him. Articles on him and his work are rife with his own hyperbolic denials of any special genius.

The pride he would express instead was in his work ethic—one that must have been taught him during those earliest years. His own reported estimates of his output range from fifty to one hundred pictures a year for more than fifty years.[12]

Early Work and Training in Art

The work ethic evidently set in early. In response to his father's admonition, he is said to have taken any sort of commission offered to him, from copying clamshells for a scientific treatise, to making portraits for friends, to painting copies of old masters for art dealers.[13] He painted on the second floor of his father's church, in a space which had been devoted to a reading room for Great Lakes sailors.

He initially shared the chamber with the sailors during the day, chatting with them, hearing their tales, and learning to work in the presence of others without discomfort. But he seems to have gradually taken over the space as a private studio. At the age of eighteen he was given his own brass and copper key to the church, so that he could repair to the studio and paint at any hour of the day or night. He shared the studio for some time with another Detroit artist, Arch Wigle, to whom he passed the key when he left for Alaska.[14]

Though he worked hard at his painting commissions, the young Ziegler was also forced to take other jobs to make his living as he reached his twenties. And again, his choice of work would prove perfect for his future life in Alaska. He spent his summers working in the woods, in logging camps in upper Michigan. Though small for the work—just a few inches over five feet and no more than one

Eustace P. Ziegler portrait, 1913-14
"Photo taken by Arch P. Wigle at Mariner's Church, Detroit, 1914. I was on furlough from Alaska."

hundred thirty-five pounds—he worked hard, and he developed both an understanding of hard-working men and a love of the outdoors.

His summer work provided valuable experience, needed money, and the opportunity to sketch in new territory. Some of the sketches from these summers became paintings in the winters in his Detroit studio, and he took lessons at the Detroit Museum of Art (now Detroit Institute of the Arts), studying with Francis Petrus Paulus, Ida Marie Perrault, and Joseph W. Gies.[15] An oil on canvasboard painting in this exhibition dated 1903, *Untitled-A Fashionable Young Woman*, is probably typical of the work he did under instruction during this period.

The Call to Alaska

Ziegler's pattern of remunerative summer labor, sketching when time and energy allowed, followed by winter painting and taking what commissions presented themselves, continued into the summer of 1908. A small photo from

CHRIS AREND

Untitled—A Fashionable Young Woman, 1903
Oil on canvasboard, 24 x 18 inches

the period, of a rude lumbering camp in northern Michigan, bears an inscription in the artist's hand—"Nelson's Camp—1908 or 1907—I worked in this lumber camp for 6 weeks. On Bois Blanc Isl., Mackinac Straits. 1.00 per day. I painted Aug. Sept. Oct. Nov. I took this photo. I got fired. Said I was too light for the work!! EPZ!!"

Whether this incident, the approaching specter of his thirtieth birthday, or some combination of these and other factors provided the impetus, the artist clearly began about this time to take stock of his life, or at least to think about new adventures. A 1940 article says that he began to make plans for a canoe trip through the wilds of northern Ontario, to James Bay, but by chance stumbled onto the book *Lords of the North*, by Agnes Laut,[16] and upon reading it was fired with a desire to visit Alaska.[17]

This bit of serendipity, if true, might have come to naught if not for another coincidence. Ziegler had heard personal accounts of Alaska before, and he did not have to look far for ideas to pursue the dream of heading North. Peter Trimble Rowe, Bishop of the Episcopal Diocese of Alaska, was well known to the Ziegler family. Rowe and his wife Dora had lived in Michigan for thirteen years, serving the mission at Sault Ste. Marie from 1882 to 1895, when he was elected first American Bishop of Alaska. The Reverend Paul Ziegler, Eustace's father, was in fact among the twenty-three church colleagues and friends in the Detroit clericus who signed a letter of congratulations to Rowe upon his election, "as a reminder of the happy years we have spent together."[18]

At the time of Rowe's appointment to the post, the Episcopal Church had only three missions in Alaska, two in the interior and one in Point Hope, on the Arctic Ocean. Settling in Sitka but traveling indefatigably throughout the huge territory, Rowe quickly began to expand the presence of the Church throughout Alaska. The huge influx of settlers brought by the Klondike gold rush and other precious metal strikes, and the boom towns that began to grow up overnight in the waning years of the 19th century and beginning years of the 20th, added fuel to the missionary fire. Rowe was looking for workers to carry on the church's work.

The young Ziegler wrote to him in 1908, offering his services. Rowe was looking for men who could not only do the spiritual work of

Nelson's Camp, 1908 or 1907
"I worked in this lumber camp for 6 weeks. On Bois Blanc Isl., Mackinac Straits. $1.00 per day. I painted, Oct.-Nov. I took this photo. I got fired. Said I was too light for the work!! EPZ"

serving as missionaries, but who could live the rough-and-tumble lives of the pioneer territory. The son of an old clerical colleague, writing from a crude lumber camp in the Great Lakes region, would probably have seemed like a good bet even if he had not been "informed by certain of his own old and respected friends among the lumbermen of the North Woods that this young man was a 'regular feller.'"[19]

Ziegler quickly received a positive reply, and he wasted no time in taking advantage of it. He would write years later, in a 1924 issue of *The Alaskan Churchman*, a thinly veiled autobiographical account of his reactions to the Bishop's positive response.[20] Leaving his Michigan lumber camp after a losing fist fight with his French Canadian foreman, he traveled by Mackinac boat to the mainland and then by southbound freight to his family home in Detroit, where he informed his father of his "desperate but noble decision."

Eustace had seen all three of his brothers take orders in the Episcopal ministry and had clearly thought for some time about that possible path. But his predilection was neither for city congregations nor for city life. He admired the clergy who worked in Michigan's North Woods, and in making his decision to take on missionary work in Alaska, had "decided for decent, respectful reasons that the Great Unwashed were much more worth being saved than the Great Washed, and though dangerous were much more interesting."[21]

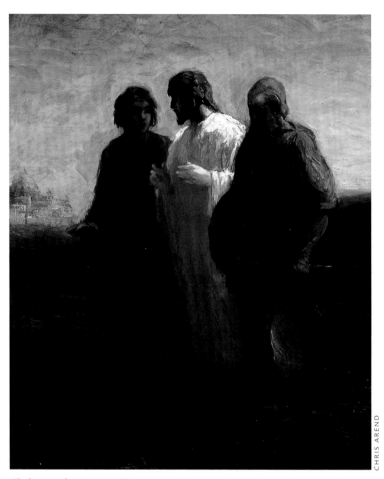

Christ on the Way to Emmaus
Oil, grisaille on paintboard, 14 x 12 inches

CHRIS AREND

Before the end of the year, he was on his way to Alaska. His December 30, 1908 letter to Joshua Kimber, Secretary of the Episcopal Church in America, from the Ziegler family home at 178 Henry Street in Detroit, marks the beginning of his journey north:[22]

Reverend & Dear Mr. Kimber:

Am leaving Detroit tonight at 9:15. Will spend tomorrow at Chicago with my cousin and friends. Leaving at 6 p.m. Dec. 31 for Seattle.
Sincerely yours,
Eustace P. Ziegler

The colorful 1924 *Alaskan Churchman* account describes four days' Pullman car travel to Seattle, including a night of good fortune,

gambling with three fellow travelers put off their guard by his mention of the missionary work that lay ahead. After another night with an old Detroit friend in Seattle, he boarded the S. S. *Yucatan* for Cordova. A week's voyage in January storms and snow across the Gulf of Alaska was followed by a three-day anchorage, waiting for clouds to clear the passage by the coast at Mt. St. Elias. With the lifting clouds, anchor was weighed in five minutes, the *Yucatan* was in Cordova harbor in twelve hours, and Ziegler's Alaska adventure began.

An Alaskan Ministry
Cordova and the Red Dragon

To understand the life Ziegler led in Cordova, it is important to know a bit about the character of the town at the time of his arrival, and even more important to understand the nature of the Red Dragon, the remarkable institution of which he was to take charge.

Cordova came into being through the dream of a railroad route from the Pacific Ocean to the big rivers of Alaska's interior. Both the Klondike gold rush of the 1890's and subsequent gold strikes from Fairbanks to Nome created a pressing demand for an all-American route from the Gulf of Alaska to Fairbanks, a point from which riverboats could travel via the Tanana and Yukon rivers to the Bering Sea coast.

Coupled with this dream was the discovery of major copper deposits in the Copper River area, near the headwaters of the Chitina River in the Interior. Of the five railroads begun from Prince William Sound, only the 196-mile-long Copper River and Northwestern Railway, stretching from Cordova north to Kennecott, was completed.[23] This railway was successful primarily because it had the backing of the Guggenheim family, who had purchased many of the significant copper claims in the Chitina-Kennecott area and needed a railroad to carry ore to the coast.

What would become the Copper River and Northwestern Railway was begun, however, not by the Guggenheims but by Michael J. Heney, the builder of the famous White Pass and Yukon Railroad during the Klondike gold rush. Around his headquarters near the Native village of Eyak, the brand new town of Cordova sprang up. From his headquarters in an aban-

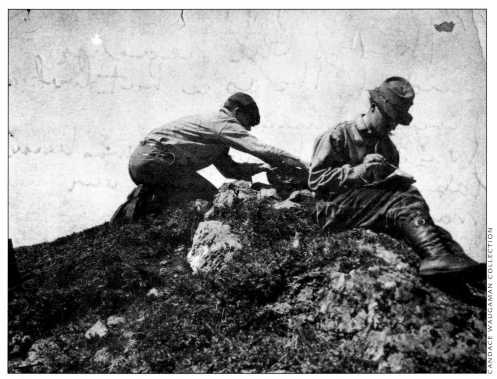

*Bill Truscott and I on top of Mt. Eyak, 1909, Cordova Alaska. Taken for
Colliers by Carlysle Ellis. [for an article on the Red Dragon.]*

*"This is the preacher and I. He is a hot looking preacher, ain't he. We didn't
know this was being taken. I am putting our names under a rock."*

doned Eyak cannery, Heney began construction in 1906. His right-of-way was soon purchased by the Morgan-Guggenheim Alaska Syndicate, however, and Heney was hired to complete the construction of the railway. The syndicate bought the townsite in 1908. Existing businesses and homes were relocated to what is now downtown Cordova, and up to 6,000 men at a time were employed from 1908 to 1911 in the construction of the railroad.[24]

Though Episcopal Bishop Peter Trimble Rowe had come to Alaska to serve primarily its Native people, the Klondike gold rush turned his mission into a two-pronged effort. Travels among transient miners, traders, construction workers, and gamblers in Alaska's boom towns had quickly convinced him of the need for a ministry to the non-Native population as well. Episcopal churches and hospitals began to spring up throughout the Territory.

Bishop Rowe was all too aware, however, of the here-today, gone-tomorrow fortunes of many of these boom communities, and he soon saw that building a local church was not neces-

sarily the most useful initial expenditure of limited resources in such towns. He noted the need for constructive recreational opportunities, reading rooms, and alternative gathering places to the rampant saloons on this new frontier. The Red Dragon club house in Cordova emerged in response to that perceived need, and it was a raging success.

The Red Dragon of Cordova was the brainchild of the Reverend Edward Pearsons Newton, the Episcopal priest in nearby Valdez. As Newton wrote in 1910:

> *The Red Dragon club house... was born in my mind on December 3rd, 1907, when, during the few hours the* Santa Clara *was in port, I walked through the old town of Eyak and took in the situation. A club house open night and day, seven days each week, seemed more useful for the early days than a church building.*[25]

It would be completed on July 14, 1908, the second building constructed in the new townsite of Cordova. It opened just four days after

completion of a saloon. The future success of the Red Dragon resulted from Newton's (and Rowe's) very accurate perception of the needs of such a community:

We wished to get away from the church idea, the faintest suggestion that preaching and praying religion might be served up daily by stealth on the unwilling, (the religion of human sympathy and helpfulness is there all the time without any advertising of itself).[26]

Descriptions and photos of the club house from its earliest days show a structure simple and well-built on the outside and warm, cozy, and flexible on the inside. Twenty-four by thirty-six feet in size, it offered, according to a well-illustrated and widely distributed 1911 article in *Colliers* magazine, a large, cheery fireplace modeled on that of the abbey of Mont Saint Michel, leather-covered window seats, couches, easy chairs, a chafing-dish, percolator, piano, pool table, and the best supply of reading materials in town.[27]

Open to everyone free of charge, the little club house became a social hub not just for Cordova, but for the entire Copper River mining district. Boxing matches, billiards, dances, smoking, and quiet conversation would give way on Sundays to church services and Sunday School, an altar being lowered from its hiding place above the rafters by block and tackle and the chairs hastily rearranged.

Though Newton himself oversaw the construction, he was needed in his own larger community of Valdez and could not stay continuously in Cordova. Writing in *The Alaskan Churchman* in November of 1908, he noted that a Mr. Leonard Todd, a Connecticut divinity school student, spent his summer 1908 holidays taking charge of the club, but that during the coming winter, when Todd would have returned to school, he (Newton) would "be able to give them but one Sunday each month. We need a priest sadly to fitly [sic] do the work, and to give the club the right kind of care."[28] Eustace Ziegler would be the answer to that need.

Ministering on the Northern Frontier

Ziegler and the Red Dragon were a remarkable "fit." Paid $750 a year, the young lay missionary seems to have felt almost immediately at home in the new community and in his club house. Perhaps the reading room for Great Lakes sailors in his father's church, the room which he appropriated for his Detroit studio, served as a good model for the Red Dragon as he molded it to his own tastes. He staged boxing bouts on Saturday nights. Both he and Newton appealed constantly for more books and magazine, especially current ones. Though free to all and requiring no membership, a strictly honorary membership could be had through voluntary donation of a dollar a month. These contributions helped support an open box in the club, always containing some money, from which those down on their luck could borrow a few dollars and repay it when able.

The club was supported by the Episcopal Board of Missions in New York, local and visitor contributions, and proceeds from special events. Dances and musical performances were both regularly planned and impromptu. Several sources relate a particularly memorable performance that captures much of the spirit and character of both the Red Dragon and its clientele.

One rainy Sunday night last fall a young man tramped into the Red Dragon about nine o'clock from a surveyor's camp fifty miles inland. "I couldn't stand it any longer," he said. "I just had to get to a piano."

He played—and played well—with the eagerness and delight of a very hungry man at a good dinner till midnight, when the place was closed. Next morning he was sitting on the step when they came to open the doors. He played till noon without stopping. Then rising, he put on his slicker and sou'wester and, waving a laughing goodby to the roomful of listeners, started on his long tramp back to camp.[29]

Within two years of his arrival, an article on the Red Dragon in *Colliers* magazine affirmed, "Mr. Ziegler is as peculiarly suited to his unique post as the club is suited to the town. He is familiar with several hundred of the English-speaking laborers of the line and has the rare faculty of meeting them on such a footing of equality as to gain their unreserved friendship."[30] He was soon known to everyone as "Zieg," the name which stuck with him the rest of his life.

Zieg's territory extended well beyond the Red Dragon and Cordova, stretching the

Alaskan Summer
Oil on canvas, 24 x 20 inches

MICHAEL WALMSLEY

length of the 196-mile Copper River and Northwestern Railway and some 60 miles east to Katalla. Within five months of his arrival in Cordova, he traveled with Newton to all the railroad construction camps, and he went on his own regularly thereafter by rail, snowshoe, dog team, boat, and on foot.

And Zieg got things done. In a 1910 letter to Bishop Rowe, he gave a colorful account of a trip up the line to Chitina, seeing, "I think... every man who had ever been in the Dragon," and fielding their questions about when he was going to build a satellite Dragon club house in Chitina.[31] By October of the same year he was overseeing its construction. His 1910 sketch of the new Chitina club house appeared on the back cover of the February, 1911 issue of *The Alaskan Churchman*.

As Katherine Wilson wrote in 1925, looking back on the legacy of Ziegler's ministry in Cordova, "In the turbulent days of those early years Eustace Ziegler became known and idolized the length of the Copper River Valley. He was every man's friend, admired, respected, sworn at and fraternized with for his dauntless courage, his lightning wit, his loyalty, humanity, and good fellowship."[32]

Ziegler's quick success at winning the respect, affection, and trust of his fellow pioneers was no doubt due in part to his excellent outdoor skills and love of travel in the wild country. A 1909 photograph shows him at the summit of Cordova's Mt. Eyak with Cordova resident Bill Truscott, just months after his arrival. Truscott wrote on the back of the photo, "This is the preacher and I. He is a hot looking preacher, ain't he? We didn't know this was being taken. I am putting our names under a rock."[33] The evident delight at having a preacher who would dress like a miner or surveyor and climb mountains for fun comes through clearly in the brief note.

The same love of fun and adventure comes through in Ziegler's many accounts of his travels in *The Alaskan Churchman*. In the letter to Rowe about his trip to Chitina, published in the August, 1910, issue, his account of the return trip to Cordova shows clearly both his love of the thrills inherent in frontier travel, as well as his own considerable skills at painting images with words.

I had the finest ride ever in shooting down the

Rapids of Wood's Canyon. The other two boys having gone on, five of us got in the boat and it took us but four hours to get from Chitina to Teikel, a distance of 32 miles. We stopped twice, once at 22 and once at 114. We left Chitina at 3:00 a.m. having had a fine breakfast of greyling caught on the day before from the little lake in the townsite... A.O. Johnson, the Resident Engineer of Chitina was in the boat coming from Chitina, also three of his men, and due to his skillful management at the helm we are not now playing "Golden Harps." Through the canyon we all worked pretty hard. My hair grew considerably for a couple of minutes and Johnson sent word back to the next boat not to try to make it.[34]

As Ziegler became more settled in his work, he soon began to contribute articles of his own to the *Alaskan Churchman*, and to the Episcopal Church of America's publication *The Spirit of Missions*. A couple of excerpts serve to show the colorful wit and unconventional way with words that probably won him as much affection as his outdoor skills. In "Two Mushers and an Ordination," published in *The Spirit of Missions*, he describes the ordination of his brother Winfred, who followed him to Alaska. Winfred arrived in Valdez to take the place of the retiring E.P. Newton in August of 1911.[35]

Two mushers are traveling the Valdez-Fairbanks trail; one in the lead on snowshoes making a way for the six dogs and the heavily loaded Yukon sled...

...I say, "Two-step, how long we got?"

"We're doing fine; we'll hit Valdez at 9:30... Eleven days ain't bad for the trip..."

I say, "Two-step, He's agoin' to ordain that young feller we seen buryin' 'Shelly' the last time we hit this here camp... The kid's from 'Nee-York, but he's on the square. His brother has the Red Dragon at 'Cordovy'..."

I say... that young feller is the fourth son of his father to go in for sky-piloting. Their old man ran a church school back in Michigan. Young Marshall, at the hardware store, used to get 'tanned' by him occasionally..."

...The ordination service lasted about an hour and a half... The bishop preached with his usual power, direct and vital words, inspiring as always to his companions of the trail. The bishop needs no introduction to anyone in Alaska; they all know

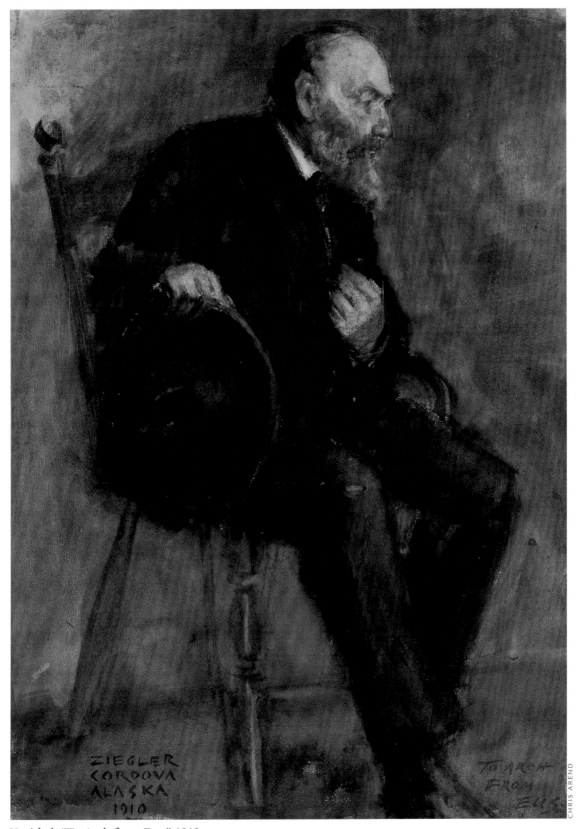

Untitled–"To Arch from Eus," 1910
Watercolor and gouache, 21½ x 14¾ inches

him. As he passed down the hall after taking off his vestments, the first man to greet him with the words, "Hullo, partner!" was our friend "Two-step." The last time they had met they were driving dogs in opposite directions through the white wilderness, but each knew the other as a real man, resourceful and courageous.[36]

An even more offbeat account is Ziegler's tale of a missionary trip to the Bonanza Copper Mine, which he wrote through the eyes of "Rags," an Airedale terrier. It begins

Maybe you know me. I'm "Rags," an Airedale terrier. I have three good legs and one bad one. I look melancholy because I travel around with a missionary. I followed him all the way to the Bonanza mines, but I didn't know that he was going to go so far. At mile 149 my bad leg gave out completely and a fellow remarked that my name should be "Thirteen," Someone asked, "Why?" and the fellow replied, "Cause she puts down three and carries one."[37]

Religious Pictures

But Ziegler's skills were not limited to mission work and colorful word pictures. Despite his evident toil at his ministry, he found time to continue his art. It is significant that one of the earliest Alaskan photos of Ziegler, the 1909 photograph atop Mt. Eyak with Bill Truscott just months after his arrival in Cordova, shows Ziegler sketching. Indeed, the characters he met, the scenery through which he traveled, and the raw activity of frontier development provided rich material for an artist who had yet to establish his own personal style and direction.

Ziegler's earliest known Cordova paintings are very akin to those he was doing before he arrived. An accomplished but quite academic watercolor and gouache, signed "Ziegler/ Cordova/Alaska/1910," now in the collection of the Anchorage Museum of History and Art, was painted for Arch Wigle, his old studio-mate in Detroit.

Of quite a different character were a series of eight oil paintings on glass done by Ziegler in 1909-10 on the windows of the cabin he shared with a Cordova man named Ralph P. Stewart. Translucent enough to be illuminated

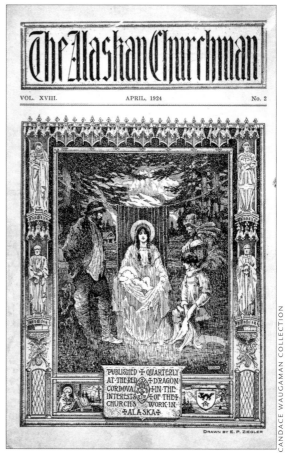

The Alaskan Churchman, *Vol. XVIII, No. 2, April 1924. Cover drawn by E.P. Ziegler*

by sunlight somewhat like stained glass, the eight pictures feature a bizarre range of images from an Indian chief in feathered headdress to a devil, knights, a monk, a snake, mock heraldic designs, and dramatically lit landscapes. Most incorporate mysterious doggerel written by the artist.

Stewart removed the painted windows when he left Cordova and took them with him. They lay forgotten in his basement, and subsequently his daughter's, for fifty years before being rediscovered shortly before Ziegler's death.[38] They were purchased by the Frye Art Museum in Seattle in 1983.[39] Though none of Ziegler's paintings before or after resemble them in any degree, they are in many ways similar to the heraldic designs he would later devise for the cover of *The Alaskan Churchman.*

He also did a number of religious pictures during his first years in Cordova, continuing

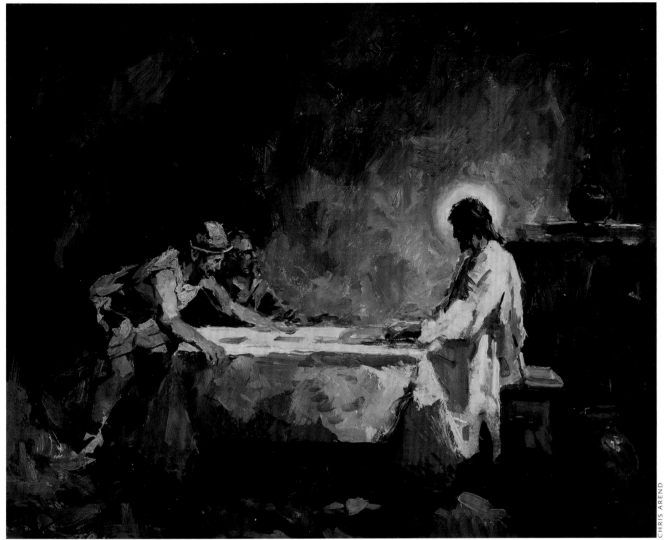

Untitled–Breaking Bread at Emmaus
Oil on board, 16 x 20 inches

to illustrate the major Biblical themes he had treated in previous years. Some were of his own composition, and others copies of old master paintings. A favorite theme was "Christ at Emmaus." At least two pre-Alaskan paintings by Ziegler of the theme are known. A 1905 painting of Christ at Emmaus, reproduced many years later in *The Alaskan Churchman*[40] is stiff, pious, and a stereotypical Bible illustration. A related image, *Christ on the Way to Emmaus*, a 10" x 11½"oil grisaille on paintboard signed and dated 1906, is also typical of religious illustrations of the period. It bears few indications of a developing personal style, but is more painterly and the figures more natural.[41] Whether taken from the images of old masters or of his own devising, Ziegler's early

religious paintings employ his own version of the rich chiaroscuro–revelation of form by modeling from dark to light–of Rubens, Rembrandt, and other Baroque era painters that he admired.

This intense light-dark contrast would remain a feature of the religious paintings Ziegler did throughout his career, but the undated oil on board *Breaking Bread at Emmaus*, certainly painted after his arrival in Alaska, shows the artist bringing to his religious scenes a much more personal character. *Breaking Bread at Emmaus* bears more resemblance to one of Ziegler's scenes of card-playing or gold-weighing prospectors than it does to the Sunday School-book religious pictures of his pre-Alaskan period. The figure at the far left looks

especially "Alaskan." It looks more like a portrait of a specific frequenter of the Red Dragon than any conventional depiction of the disciples at Emmaus.

Ziegler continued to paint copies of old master religious pictures throughout his Alaskan years, however, primarily for Alaskan churches. In addition to scenes of this sort painted and drawn for the Red Dragon shortly after his arrival, he painted copies of Peter Paul Rubens' *Crucifixion* and a *Nativity* for St. Stephen's Church in Fort Yukon[42] and a copy of Rubens' *Descent from the Cross* for his own St. George's Church in Cordova[43] before 1920. In an appreciative profile of Ziegler and the Red Dragon in his 1920 *The Alaskan Missions of the Episcopal Church*, Archdeacon Hudson Stuck wrote:

> ...he has expressed his willingness, as his leisure shall permit, to paint altar-pieces for every church in Alaska. If someone of artistic sympathies would bear the not inconsiderable charge, nowadays, of pigments and canvas and frames, our churches and even our Indian missions, might rejoice in such adornment and profit by such graphic representations of the Christian faith.[44]

In addition to these examples, a copy of Raphael's *Madonna of the Grand Duke* was done for the Church of St. Mary's by-the-Sea in Pt. Pleasant, New Jersey in early 1922, shortly after Zieg completed a similar work for Christ Church in Anvik, Alaska.[45] Nor did production of religious pictures cease with his leaving the ministry and Alaska. His later sacred scenes range from a small, circa 1948 oil on board *Crucifixion* now in the Martin of Tours Collection of St. Martin's Abbey in Washington state,[46] to a large commission for the baptistery at St. James Cathedral in Seattle.

Painting the Life of the Alaskan Frontier

As appreciated and sought after as Ziegler's early religious paintings were, they were not to become his greatest contribution to the art of the northern frontier. He is known today as one of Alaska's greatest painters not for his *Crucifixions* and *Nativities*, but for his extraordinary ability to capture on paper and canvas the character of the people with whom he shared the adventurous life of early 20th century Alaska. It is in that arena that he carved out, from his earliest Cordova days, a unique niche in the art of Alaska and the Pacific Northwest.

Eustace Ziegler and Sydney Lawrence

Eustace Ziegler's work is most often compared to that of Sydney Laurence, the other great painter of early 20th century Alaska.[47] As noted in the introduction to this volume, each has his champions as Alaska's foremost historical painter. Their time in Alaska overlapped significantly, Laurence arriving just six years earlier, in 1903, and quitting full-time residency the same year as Ziegler, in 1924. It is not widely known, but is a remarkable historical coincidence, that Laurence happened to be in Cordova the day Ziegler arrived and that the two met. In an audio recording of an hour-long interview now on deposit in the Alaska State Library,[48] Ziegler recounts that first day in Cordova, confirming many of the events and impressions widely reported elsewhere, from being met at the dock by E.P. Newton, whom he characterized as "a real gentleman," to the "ladies" on the steamer carrying monkeys and parrots in cages. But he goes on to note that later that first day, he met Laurence.

Ziegler liked Laurence immediately, he joked, because like him, Laurence was a small man, each of them about 5' 3" or 5' 4". But Zieg also noted Laurence's "sweet character," something which he insisted was more important than being a great painter. Laurence was in Cordova for several months before heading up toward Mt. McKinley to paint the mountain.

Zieg makes little of the friendship between the two, saying that they were never intimates and never painted or sketched together, but that they talked about painting when they met over the years. In the interview he is appreciative of Laurence's work, saying that particularly as a landscape painter, "I think he's just tops," and that "Laurence's best paintings are great."

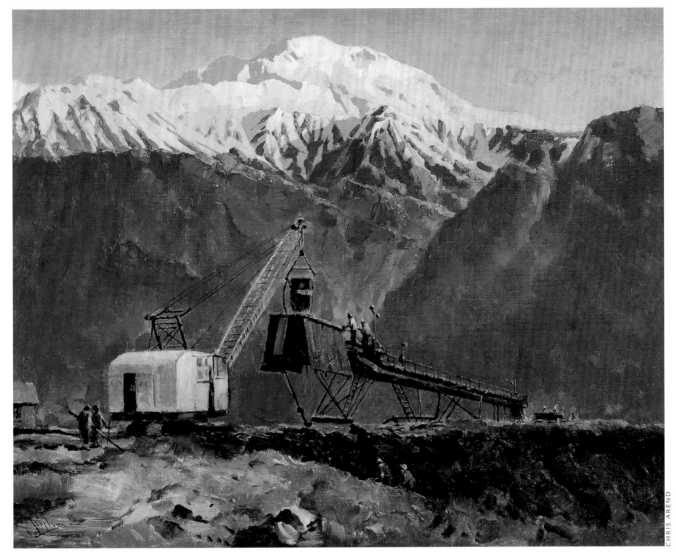

CHRIS AREND

Mount McKinley with Mining Camp
Oil on canvas, 16 x 20 inches

Ziegler notes in the interview that Laurence's paintings were on exhibit that first day in Cordova, in E. A. Hegg's Photo Studio. He credits Laurence, as he did on many other occasions, for Alaskans' interest in good art, saying that before the "rough, tough prospectors" got acquainted with Laurence's work, they thought art was not for them. He says, in fact, that he is loath to admit to "a rough kind of person" that he is an artist, and that for much of society art is seen as a "disreputable profession."

This chance meeting may have been important for the young Ziegler (sixteen years Laurence's junior) in more ways than one. It had to have been an affirmation that even in this near-wilderness, in a raw town with only two solid-roofed buildings at the time of Zieg's

arrival, it was possible both to make significant art and to have it taken seriously. A 1940 account in the *Bellingham Herald*[49] tells the story of Laurence's 1909 encouragement by Hegg, who allowed him to use his facilities for six months while producing one of his largest canvases, the 4' x 16' *Cordova Bay.*[50] At almost no other time in Cordova, and in no other Alaskan community at the time, would Ziegler have been confronted with such a striking example of artistic ambition and accomplishment.

Confronting Laurence and his work those first few months may, too, have helped confirm Ziegler's already clear preference for paintings not purely of the landscape, but of people in the landscape.[51] Perhaps fortunately, even though Ziegler was yet to develop his own vision of

Untitled—House with mountains in background
Watercolor, 4 ¼ x 6 ½ inches
Inscribed: "Ziegler, Valdez, Alaska 1912"

Untitled—Barn, fence, mountains
Watercolor, 5 x 7 ½ inches
Inscribed: "Ziegler, Valdez, Alaska 1912"

Alaska, his fascination with the life of the frontier and its many characters was far stronger than his enchantment with the land itself. It was in probing the character of the place, its inhabitants, and the struggle to live and work on the land that Ziegler would make his mark.

That emphasis is markedly different from Sydney Laurence's vision. Laurence's contribution to Alaskan art was to define the character of Alaska as wilderness. His paintings are often unpeopled, and the figures he does represent are almost invariably small and largely symbol-ic. Laurence's message was that people are small and the land is large. It is a vision of Alaska as a lonely landscape, not so much hostile as indifferent to the relatively small scale activities of solitary trappers, prospectors, and Native people.

Eustace Ziegler arrived bearing a different set of values, different interests, and a fundamentally different mission. Both as a minister and as a painter, his mission was to people. Though he depicted what may be seen as the generic activities of a frontier railroad boom town, the people he painted are almost invariably individuals. While they function for viewers of Ziegler's day and our own as symbols of northern frontier life, they are never symbols alone. Neither denigrated nor heroized, they represent individuals finding a way to live in a place, climate, and era that posed formidable challenges.

Even the landscape Eustace Ziegler painted was an inhabited one. We see him firmly making that choice in some of the earliest Alaskan paintings in the exhibition, a pair of 1912 images of Valdez. The town of Valdez lies in a setting as dramatic as that of any town in the world, with steep, snow-covered mountains and glaciers plunging into beautiful Prince William Sound. But Ziegler relegated the snowy peaks to a distant background, choosing as his subject the barns, fields, and roads of the small city.

Balancing Art With the Work of the Church

The 1912 trip to Valdez on which Ziegler painted those early watercolors may have been a family visit, and not just to see his brother Winfred. On February 28, 1911 Ziegler had married Mary Neville Boyle. She had come to Seward from Dover, Delaware in 1906 and later moved to Valdez to live with her brother Frank Boyle, a physician and pharmacist who also served as city councilman, mayor, and postmaster.[52] A postcard (page 31) shows her at work in the Valdez post office. After their marriage, Mary Ziegler shared her husband's missionary work, focusing her attention on the Native Alaskan women and children of the area, while Eustace's work was primarily among the miners and railroad men.[53]

Ziegler was ordained a deacon by Bishop

Rowe just ten days after his marriage, on March 10. About the same time, he made a painting sale which would not only put money in the newlyweds' pockets, but prove to be an important contact that a decade later would change their lives. Ziegler had been showing his work and selling it to tourists in the window of Bill Fursman's drugstore for some time before E.T. Stannard, president of the Alaska Steamship Company, spotted a 16" x 20" mountain scene and purchased it on the spot for $150.[54] He received his first commission about the same time, for a series of murals in Cordova's Lathrop Company theater.[55]

Despite the apparently growing success of his artwork, the Zieglers remained committed to their mission work. As Cordova grew and the need for a priest and an established church loomed, Ziegler decided to study formally for the priesthood. In 1914 he, Mary, and their young daughter Elizabeth left for Berkeley Divinity School in Middletown,[56] Connecticut. Following two winters' study, interspersed with summers in Cordova, he was ordained to the priesthood by Bishop Rowe in Juneau, Alaska, on September 17, 1916.[57]

Less than two years later, on April 20, 1919, the church Ziegler himself designed, St. George's, was consecrated.[58] But Zieg was apparently growing restless as he tried to balance his growing excitement about his artwork with his commitment to the church. Just a year after St. George's opened, he applied for and received a year's furlough. With his family, which now included a second daughter, Ann, he left Cordova on June 20, 1920, to spend the summer at Pointe Aux Pins, Michigan.

After so much isolation in Cordova, however, the Zieglers were eager for a more stimulating environment. They wanted to try living in New York, but wondered how they would afford to live there. On August 19, Mary wrote to John Wood, Executive Secretary and Secretary of Foreign Missions for the Episcopal Church in America, letting him know that Eustace had applied to the Yale School of Fine Arts and been accepted as a third year student. Concerned about money on which to live, she asked Wood if there was work that he could do for the *Spirit of Missions*.[59]

A voluminous correspondence over the next year between the Zieglers and officials of the Episcopal Church in America documents a tug-

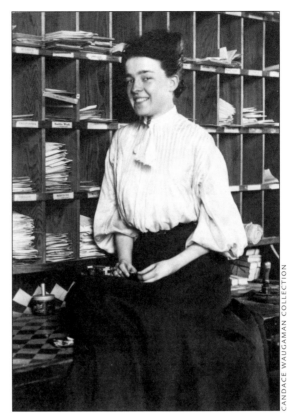

Untitled—Mary Neville Boyle postcard
Inscribed: "Yours Truly—Mary Neville Boyle
Valdez, Alaska"

**Untitled—Conté crayon drawing
of Mary Boyle Ziegler**
Conté crayon, 31 x 29 inches

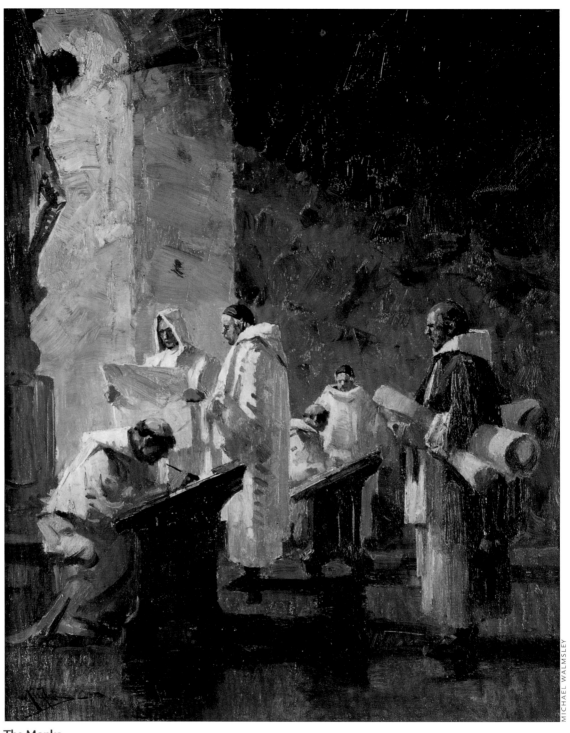

The Monks
Oil on board, 20 x 16 inches

MICHAEL WALMSLEY

of-war for Zieg's time and attention. He wrote articles for the *Spirit of Missions,* did speaking engagements throughout New England to raise money and recruit missionary workers, and squabbled with Wood and others in the Church about reimbursement for his expenses. He did study at Yale, with William Sergeant Kendall, after spending a month painting in Provincetown, Massachusetts, at the urging of the artist Gerrit Beneker. But much of the spring and early summer was spent in Detroit, attending his father, who was gravely ill, and shuttling from there to speaking engagements in Connecticut. His father died July 18, and the Zieglers returned to Cordova in August.

It cannot have been a very satisfying year in terms of art training. Between money worries and a very full lecture and travel schedule, there could not have been time for the concentrated work that such an opportunity should have afforded. But it did give Ziegler a taste of the wider world of art, and the constant wrangling with the Church hierarchy might well have hastened his leaving both Cordova and the ministry just a few years later.

Zieg tried once again to incorporate his art interests and church responsibilities by assuming the editorship of *The Alaskan Churchman* in 1922, filling the magazine with examples of his work, and starting an enterprise he called "The Alaskan Churchman Scriptorium." A personal introduction to his first issue as editor, January 1922, announced his intention of replacing halftone illustrations with zinc etchings "executed in our scriptorium by our own artists."[60]

The inside cover bore an advertisement for the scriptorium. Within a flowered border with a monk reading a bible at an altar, it read, "Our artists are prepared to execute altar pieces of original design, oil paintings, bookplates, illuminations, and illustrations. The Alaskan Churchman Scriptorium. The Red Dragon. Cordova, Alaska."

Though the experiment was a noble one, and it produced a remarkable publication for the next two years, it ultimately failed to satisfy his artistic needs. He was on a dogsled trip to Chitina with Bishop Rowe when his wife Mary received a telegram from E.T. Stannard of the Alaska Steamship Company, offering him a commission to execute a number of large paintings for the company offices in Seattle. She forwarded him the wire, attaching a message of her own saying, "We will leave on the *Alameda* on February 28th. I am going with you." [61]

The Zieglers returned to Cordova briefly upon completion of the commission, but their time in Alaska was over. On July 5, 1924, Zieg sent his letter of resignation to John Wood of the Episcopal Church in America,[62] and the family left for Seattle on September 23. Though Ziegler wrote Wood in October outlining his intention to return to New Haven, "where I can get my degree in one term,"[63] by December family matters had again intervened. Mary's mother had suffered a stroke, Eustace was painting pictures for the Alaska Steamship Company ships, and the die was cast. They would stay in Seattle, and Zieg would become a major figure in the Seattle art scene.

After Alaska

Many writers on Ziegler have speculated about his reasons for leaving, but the reasons all lead to the same conclusion. Cordova was no longer an adventure. It was not the rough and tumble place it had been when he arrived, and it now just seemed confining, to both him and to Mary. Though he wrote of dissatisfaction at his own missionary performance in his resignation letter to Wood[64] and joked frequently that he had resigned "ten minutes before Bishop Rowe fired me,"[65] the Bishop himself wrote of him:

To know Eustace Ziegler was to know an unforgettable person. Few workers in the Alaska Mission field were better known, or more beloved by the men who follow the frontier. He possessed a rich sense of humor, was an unique story teller, a diligent pastor and a lover of mankind.[66]

Seattle was a new adventure, and he embraced it wholeheartedly. He was a founder and the first president of the Puget Sound Group of Northwest Painters.[67] He regularly entered the annual Northwest Artists' Exhibition, winning prizes in

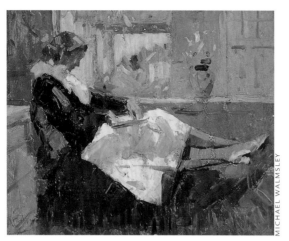

Untitled—Ann Ziegler in high school or college on porch at the Ziegler home on the street below Volunteer Park, Seattle
Oil on canvas, 8 x 10 inches

1926, 1927, 1929, 1931, 1932, and 1934.[68] Seemingly still heeding his father's early stipulation that he must be able to make a living at his work, he worked hard, supporting his family on sales of his work and teaching in his studio for more than forty years.

Within a year of his move to Seattle, Zieg was a prominent fixture in the still-fledgling Puget Sound art community. A biographical essay on well-known Pacific Northwest artist Guy Anderson confirms his central role:

A well-known and fashionable painter of Alaska and the Northwest, Eustace Paul Ziegler established a studio and school in the White Henry Stuart Building in downtown Seattle in 1925. Chief among the promising young artists the school attracted were [Guy] Anderson and Kenneth Callahan. The Yale-trained Ziegler presented a professional program of study in life drawing, still life, portraiture, and painting in nature, and provided his students access to his extensive library of art texts and color reproductions of the masters. Ziegler also took his students to visit Charles and Emma Frye's collection and the Horace C. Henry Collection Gallery on Harvard Avenue, where they saw examples of the Barbizon and German schools of painting from the end of the nineteenth century.[69]

In addition to more commissioned work for the Alaska Steamship Company, Ziegler received a number of other commissions for large scale works. Logging scenes for the *Seattle Post-Intelligencer*, large works and studies commissioned for the Washington State Press Club (now in the collection of the University of Washington School of Communications), and

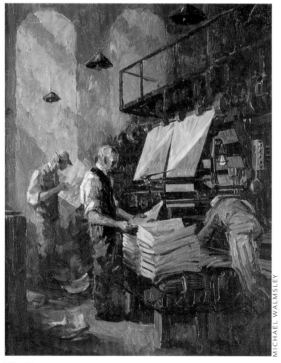

The Presses
Oil on board, 20 x 16 inches

The Radio
Oil on board, 20 x 16 inches

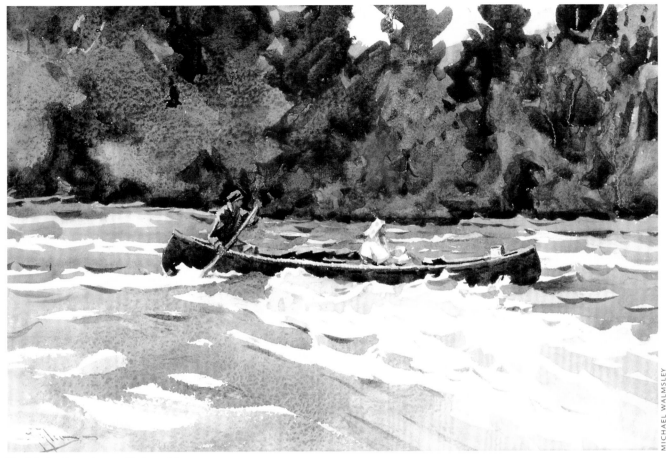

MICHAEL WALMSLEY

Untitled—Canoeing at Skykomish
Watercolor, 10 ¼ x 14 ½ inches

oils for the Baranof Hotel in Juneau are all represented in this exhibition. Other major commissions included works for Clark's Dublin House Restaurant in Seattle (most of which now hang in the Washington State Convention Center), a commission for the Miami Clinic in Dayton, Ohio, and others for the Arctic Club, Broadway High School, and the Olympic Hotel in Seattle.

Ziegler's works are well represented in the collections of the Alaska State Museum, Anchorage Museum of History and Art, University of Alaska Museum, Seattle Art Museum, and Seattle's Frye Art Museum, and examples are included in the collections of the Henry Gallery at the University of Washington, the Jersey City Art Museum, the Juneau Empire Collection, and numerous other public and private collections. In 1951 he was elected to membership in the Salmagundi Club of New York, one of the oldest art associations in the United States.[70]

Reputation and Influence

Bare facts and lists of accomplishments fall short of measuring the artist's character and influence in the Pacific Northwest, however. He was both a friend and an inspiration to other artists. Edmond James (Jim) Fitzgerald, a well-known Seattle artist who first went to Alaska in 1932, traveled more than once with Ziegler and studied with him in Seattle. Fitzgerald's studio was on the same floor as Zieg's on the Seattle waterfront. Noting the older artist's reputation, Fitzgerald recalled, "Artists and businessmen would arrive at Ziegler's studio at lunch and catch a glimpse of paint being applied to canvas. The noontime conversations were not only of painting but of philosophy and a way of life."[71] Fitzgerald is shown in the Ziegler painting *Reconnaissance*, rifle over his shoulder, one of three figures viewing a snow-covered terrain.

Zieg's most famous Alaskan pupil, however,

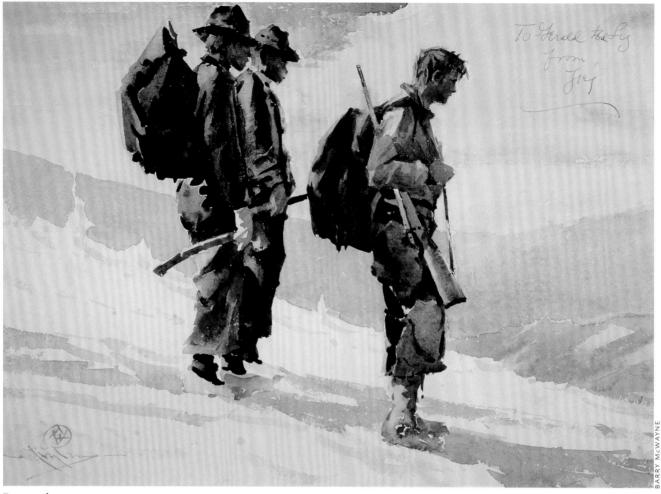

Reconnaissance
Watercolor, 10 ½ x 14 ¾ inches

was Ted Lambert, a young painter who would become one of Alaska's best known artists. Admiring Ziegler's work, Lambert was able to save enough money from a summer's mining labor to travel for a season of study with Ziegler in 1933. In 1936 the two took a major journey in a homemade boat from Fairbanks, down the Chena, Tanana, and Yukon rivers and then across the portage to the Kuskokwim River. Fortunately a number of Ziegler paintings from the trip, a Lambert example, and Ziegler's hand-drawn map of the expedition, have been located, documenting a good portion of the trip. It is an extraordinary body of work, worthy of an exhibition and catalogue in its own right.[72] The two worked together again extensively in the summer of 1939, on an extended stay in Talkeetna which is discussed in some detail in Nola Campbell's 1974 *Talkeetna Cronies*.

Another tribute to Ziegler's Seattle influence comes from Northwest artist William Cumming. In his 1984 *Sketchbook: A Memoir of the 1930s and the Northwest School*, he recalls:

> *...the Fifth Avenue Art Gallery, located on the east side of Fifth Avenue across from the Olympic Hotel. The latter gallery acquainted me with most of the well-known painters of the area at the time— Eustace Ziegler, Edgar Forkner, Paul Gustin, Paul Immel and other pictorialists as well as the avant-garde painters... Art in the area had scarcely exchanged diapers for training pants. Amateur pictorialism of the genteel finishing-school watercolor sort had only lately given way to professional pictorialism... The unquestioned master of local pictorialism, Eustace Ziegler, dominated his field much more thoroughly than Mark Tobey was ever to dominate the insurgent avant-garde.[73]*

Later in his account, Cumming recalls, "In 1936 I met Eustace Ziegler, whose heavily-impas-

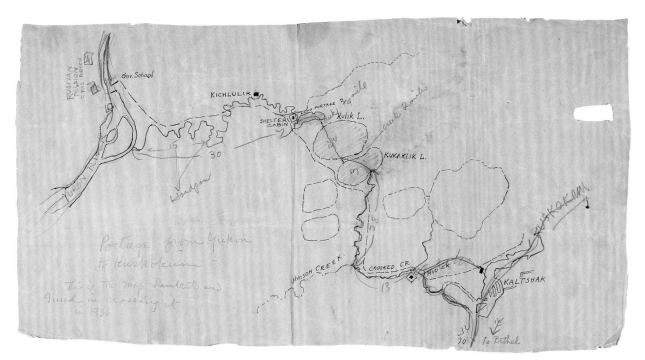

Hand-drawn map of 1936 Trip
Pen, pencil on brown paper, 16 x 20 inches

toed oils of mountains, fishing boats, Indian villages and pack trains had earned him a lucrative audience. Although he worked within the tradition of pictorialism, Zieg was a key figure in bringing to the Northwest a real sense of sophistication in use of paint, being rather a parallel to Tobey in that they both introduced us to high standards of craft, one as traditionalist, one as iconoclast." He goes on to describe a visit to Ziegler's studio, still in the White-Henry-Stuart Building at that date, in which a class of fifteen or twenty students were drawing a model—Guy Anderson—dressed in Indian robes.[74]

Looking Back at the Last Frontier

Though he quit Alaskan residency in 1924, Ziegler missed few summers returning to the land where he made his reputation and with which he always identified. He made striking paintings of the Puget Sound region, of fishermen on the sound, boats at sea, the Oregon seacoast, his family, and a host of other subjects in his prolific career. One of the few summers he didn't return to Alaska, 1931, was spent painting scenes around Mt. Rainier on a contract from the Rainier Club. But the majority of the paintings Zieg made in his Seattle studio were

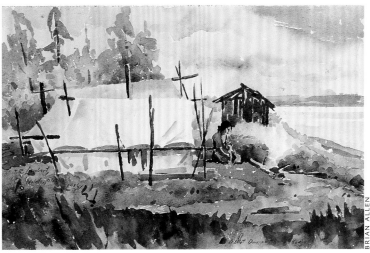

A Wet Day on the Yukon, Nulato, Alaska, 1936
Watercolor, 7 ½ x 11 ½ inches
by Ted Lambert

of Alaska, and they celebrate the life he remembered from his early days there.

Though his scenes of railroad workers, miners, prospectors, and fishermen are his best known works, perhaps nowhere do we see Ziegler's empathy for human beings as individuals more clearly than in his portraits of Native Alaskans. It is a body of work that has not been often emphasized in the little writing done on the artist, nor is it usually the first topic of con-

versation among his many collectors and admirers. But while largely overlooked, it is one of his most significant contributions.

By the late 19th and early 20th century, most depictions—both painterly and photographic—of Native Alaskans reduced them to stereotype. Few painters of the day chose Native Alaskans as a subject, usually including them as picturesque, exoticizing features in paintings focused on the grandeur of the landscape. Photographers as well, and even writers, tended either to do the same or to explore the wrenching effects of acculturation on Alaska's Native people. But Ziegler depicted Native Alaskans

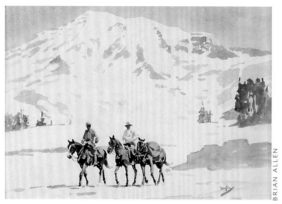

Skyline Trail—Mt. Rainier National Park
Watercolor, 9 x 12 ½ inches

neither as exotic, noble primitives nor as downtrodden exemplars of a culture under siege.

An early work like *Cordova Native,* a 1918 watercolor is a good example both of Ziegler's considerable painterly skills with watercolor and his unromantic, sympathetic insight into the character of his subjects. It is in watercolor that Ziegler shows most clearly his remarkable ability to work from life, and his excellent draftsmanship. *Cordova Native,* like virtually all the artist's watercolors, is confident and deft. With an economy of means, he renders what we are certain is a good likeness, as the young Native man is so fully alive. We can see his combined shyness, patience, and concentration on trying to sit still for the painter.

Looking at another painting from the same year—this one of a non-Native Cordovan, *Russian Priest*—confirms these perceptions. Painted with almost identical, spare means, the priest's character jumps forth in the same way as that of the Native youth. His intensity shines through the cragginess of his weathered face. Like the garment of the young Native man, his loosely sketched frock and crucifix are shorthand indications of identification, not exoticizing affectations. The fact that we are not given the name of either individual in no way diminishes their individuality, which is carried not by

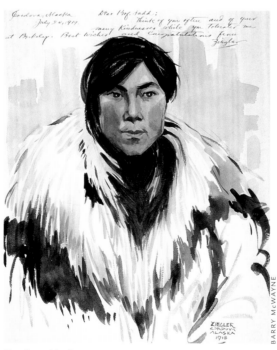

Cordova Native
Watercolor, 9 ¼ x 8 inches

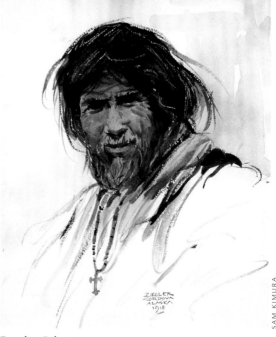

Russian Priest
Watercolor, 9 x 7 ½ inches

the picture's title but by Ziegler's insightful personal depiction.

This ability to render individuals in a way that places them in ethnic and social context without turning them to stereotype is something Ziegler never lost, especially in his watercolors. The much later depiction of an Athabaskan Native in *Russian Mission, Alaska* has the same manner. The characteristic squatting repose, cigarette, and clothing, like the high cheekbones and straight dark hair, tell us what time and place the sitter comes from, but we also feel we would know this young Athabaskan woman if she greeted us in the flesh.

Oil paint afforded Ziegler, as any other artist, a much fuller range of effects. We see him taking full advantage of this quite different medium in the powerful *Eskimo Head, Lower Yukon*. Like many of the miners and railroad workers Ziegler depicted, this woman has led a hard life, the toll of which is written clearly in her face. She is tired, perhaps from the day's struggle but more likely from a lifetime of it. But Ziegler neither romanticizes her nor makes her pitiable. Simply by reflecting the evidence written in her face and pose, he has probed her character deeply, but he has left intact both her privacy and her dignity. We are equally aware of her strength and her wear.

Working Methods

In these and other oil portraits, Ziegler builds character in part through the manner in which he handles his paint. Thick pigment and quick, lively brushstrokes usually serve expressive ends for Zieg, rather than being either a function of haste or formal innovation for its own sake.

With the exception of a brief period soon after his move to Seattle,[76] Ziegler never flirted seriously with increased abstraction of his figures or with color experimentation for its own sake. Solid modeling of form, with naturalistic colors slightly enhanced by bright bits of clothing, was to be his method throughout virtually all of his long career. But within that rather narrow means—expressive paint qualities kept subordinate to the task of realistic depiction—he consistently orchestrated in his oil paintings a rich, painterly surface, the kind which rewards close inspection with surprising bits of color and brush play. Such surfaces are all the more remarkable for the large number of paintings he produced, and for the fact that he repeated many of his best known images scores of times over decades.

Ziegler also frequently worked from photographs, often from published sources. Many of the Eskimo portraits, for example, are from

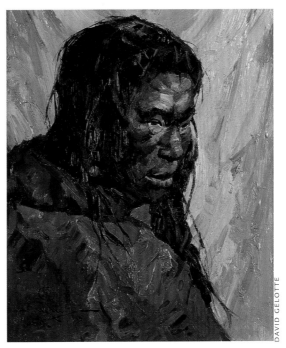

Russian Mission, Alaska
Watercolor, 10 ½ x 10 inches

Eskimo Head, Lower Yukon
Oil on canvas, 20 x 16 inches

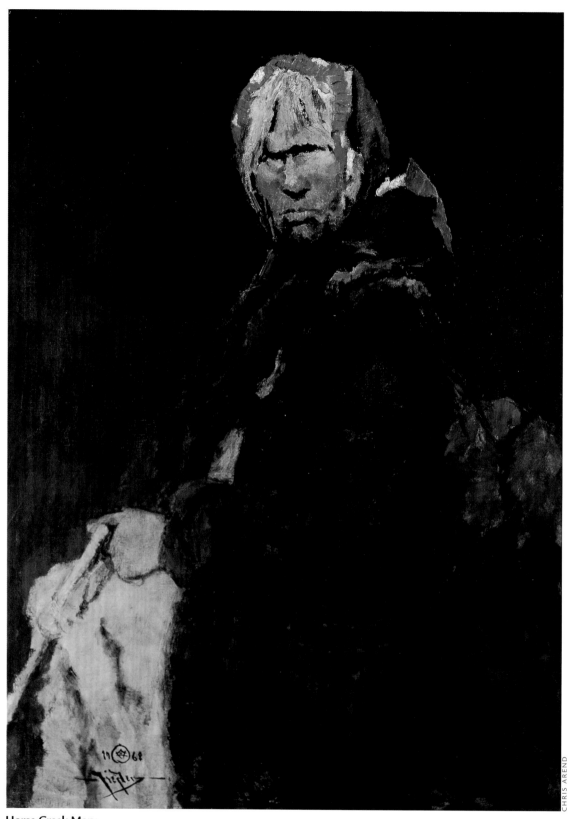

Horse Creek Mary
Oil on canvas, 34 x 24 inches

photographs in a wide variety of sources. Though he did interact with Yup'ik Eskimos in the Yukon-Kuskokwim area, many of his Eskimo portraits are clearly Inupiaq Eskimos from northern Alaska, with whom he had little contact.[77]

Among Ziegler's best-known images are several poses of "Horse Creek Mary," a very elderly, impoverished Copper River woman evidently of mixed Native Alaskan and Russian ancestry. An account of the life of Horse Creek Mary is related by Katherine Wilson in her 1923 *Copper Tints, A Book of Cordova Sketches,* which was illustrated by Ziegler.[78] One of Zieg's characteristic images of her, a full-face portrait in scarf, is clearly painted from the photograph of her which is reproduced in Thomas Jenkins' biography of Bishop Peter Trimble Rowe.[79]

This reliance on photographs might be thought by some to argue against the vitality of Ziegler's work, even though we know that great artists have worked from photographs since the invention of the camera, and from *camera obscura* images back to Canaletto, Vermeer, and before. In any case, Ziegler's paintings from photographs are often as perceptive and lively as those he created from life. It is an interesting aside on his work, not an indictment, to encounter his sources.

In the work of many artists, especially prolific ones, there is a direct correlation between date and quality. As images become familiar to an artist, revisiting them eventually becomes a chore rather than an adventure, and the loss of vitality shows clearly in the work. Ziegler was not immune to this phenomenon, and he himself often referred to the images he frequently repeated as "my Alaskan potboilers,"[80] but there is no easy correlation between his paintings' chronology and their quality.

Tanana Woman and Dog is a good example. The original models for the scene are probably an Athabaskan woman from the Wood River region named Eudoxia (often referred to as "Doxie") and her son Basil. The pair were among Ziegler's favorite, and most frequent models.[81] The painting in the exhibition is surely not his first, or even among his earliest, iterations of virtually this exact image, but it is among the finest. Not only did he do many oil versions of it in a variety of scales, but he did watercolors and an etching with drypoint of the same pose and setting as well. Yet there is

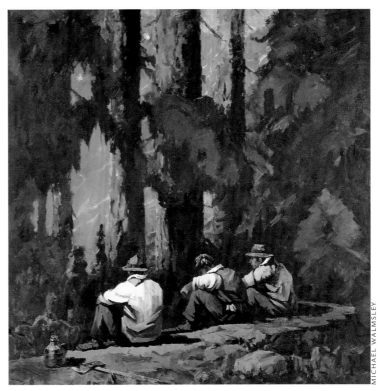

Untitled—Loggers sitting on a log in the woods
Oil on canvas, 54 x 54 inches

Untitled—Three Men in Woods
Oil on canvasboard, 16 x 16 inches

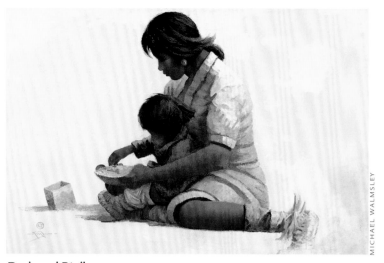

Doxie and Basil
Oil on canvas, 24 x 36 inches

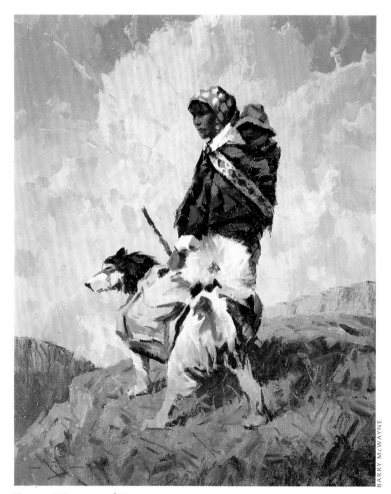

Tanana Woman and Dog
Oil on canvasboard, 20 x 16 inches

freshness not only in the image, but in the marks and surface which make it up.

How did he avoid the muddiness, sloppiness, and evident lack of joy in the work which usually characterizes such repetition? At least two factors seem to have helped him keep his work fresh. One factor was pride. Though he was constantly self-deprecating, often exaggeratedly so, when asked about his work, he was not-very-secretly a proud man—proud of his art and sensitive to criticism. So though he would say,

> There are a lot of good painters in Alaska, but they're not as old as I am, so they haven't the reputation I have. That's the only difference.[82]

or

> I've never painted a masterpiece. I'm a ham-and-egg painter. But I want my friends to overestimate me and I want every one of them to lie like a gentleman.[83]

He would also insist that "if you don't paint for money, you'll make money,"[84] would flare up easily at criticism, and would in fact maintain his standards rigidly when they were attacked.

So at least a part of Zieg's unwillingness to turn out sloppy work was pride, and this element was almost certainly coupled with the work ethic he developed as a young man. A third, additional factor, however, may have been his working method. Many small pencil studies exist for Ziegler's larger compositions, and they are thoroughly worked out in the extreme. They often include a tight grid from which he could enlarge the drawing to the size of the canvas on which he was preparing to work, while keeping the proportions exactly the same (a time-honored method used, for example, by Renaissance masters when translating their figure studies to large fresco scale). Indeed, many larger canvases show traces of the grid on close inspection.

Ziegler used the grid not as a crutch. One has only to examine the watercolors he did in the field, the extraordinary 1936 pictures he made on the trip down the Yukon and the Kuskokwim with Ted Lambert, for example, to see that he was a remarkable draftsman. Nor is it a shortcut. The gridding process itself, when done with Ziegler's rigor, is tedious and time consuming, much more so than sketching in an

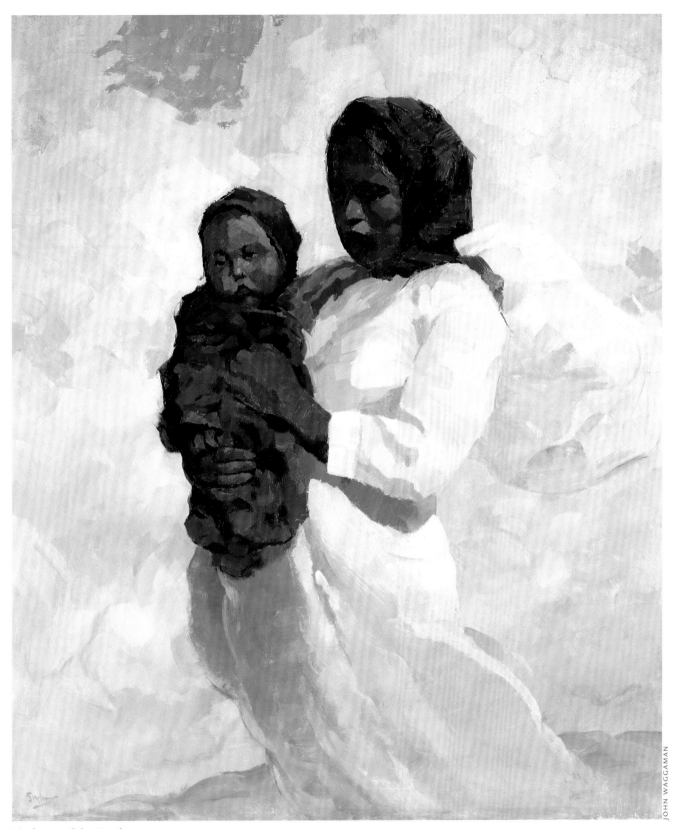

Madonna of the North
Oil on canvas, 40 x 36 inches

Untitled–Raven Totem
Oil on canvas, 12 x 10 inches

MICHAEL WALMSLEY

paint almost "abstractly" in terms of the way he thought about application of the paint itself.

Eustace Ziegler's Legacy

In addition to his private sales and commissions, Eustace Ziegler's work was shown in numerous group and solo exhibitions during his many years of residence in Seattle. His first one-man show at that city's Frye Art Museum opened in May, 1952, just a month after the museum's formal public opening.[85] A second, retrospective exhibition of his work had just opened two days earlier at the same institution when the artist died in a Seattle hospital on January 27, 1969. In the year before his death, he received the Washington State Arts Commission's first award for esthetic and historical contributions to the field of Northwest art. It reads:

Recognizing his significant contribution esthetically and historically to the art of the Northwest, from the early days of this century when he first journeyed to Alaska; noting the recognition that his Alaskan paintings, drawings, and prints have received in major museums in the United States and in the White House; and noting further the inspiration he has been to many younger artists, the Washington State Arts Commission hereby presents the Washington State Arts Award to Eustace P. Ziegler.[86]

Eustace Ziegler was an original. A "blue-collar" artist in the most positive sense, he insisted on the value of hard work, no compromise, and pulling his own weight. He found a way to keep both the joy of paint and the memory of experience alive in his work for more than half a century. Better than any other artist, he gave us a clear, clean insight into life as it was lived in the halcyon days of the frontier.

approximation of the image desired.

But the grid was important to him. In fact, it may have been a key factor in maintaining both his quality and his interest. A grid takes the worry and the work out of the drawing part of making a picture, leaving the artist free to enjoy the application of paint. Producing a well-worn image for the tenth or even twentieth time, Zieg did not want to have to spend his energy worrying whether this arm or that leg was a little too long. With the gridded preparatory drawing as a guide, he could paint with abandon. It enabled him to enjoy the part of the task which every painter likes — the building of the surface with layered strokes of color. Without compromising either his commitment to realism or the expectations of his buying public, he could

Notes

1. The quotes are excerpted from two discussions of Ziegler's influence in Cumming 1984, 21, 229.
2. These quotes are reported in a variety of sources. Among other references, the answer to the sour-dough question is reported in Carlson 1971, 2, and the returning to Alaska quote appears in an untitled column on Ziegler in *Alaska Sportsman* (June 1955): 29.
3. Carlson 1971, 1.
4. There are many, essentially similar, accounts of Ziegler's arrival in Cordova. This quote and the detailed description of the women, their greetings, and his reaction to them come from a newspaper story

Untitled—man and woman on beach in Laguna Beach, California
Watercolor, 10 x 13 ½ inches

published by Ziegler's longtime friend Fergus Hoffman just days before the artist's death, as a major exhibition of his work opened at Seattle's Frye Museum of Art. Hoffman, "The Active Life of Eustace Ziegler," 1969, 10–11.

5. Heilman 1965.

6. Shalkop 1977, 3.

7. This date for the inception of Ziegler's artistic leanings is widely repeated. Barker 1940, 6, makes reference to Ziegler's decision to become an artist at the age of seven. Hoffman ("Eustace Ziegler, Noted Seattle Artist, Succumbs," 1969) claims that he took drawing lessons beginning at that age and that "the boy had standing permission to skip school classes for sketching trips."

8. Wilson, "Eustace Paul Ziegler— Alaskan Painter," 378.

9. Callahan 1947.

10. Miletich 1960.

11. Hoffman 1956. The article has the very unromantic title, "Artist Calls Self Hack, Sells Product Easily."

12. See, for instance, Carlson 1971, which has him estimating that he had painted or drawn more than fifty works a year since he began selling professionally at the age of twen-

ty, and Hoffman, "Eustace Ziegler, Noted Seattle Artist, Succumbs," 1969, which uses almost the same words, but substitutes "one hundred" for "fifty" as his own estimated output.

13. Wilson, "Eustace Paul Ziegler— Alaskan Painter," 378.

14. Heilman 1965. This source, an article on the keys being returned to Ziegler on the death of Wigle, includes a photo of Ziegler, taken just a couple of years before leaving for Alaska, in his studio in the Mariners' Church.

15. Ziegler's study at the Detroit Museum of Art and the identity of his teachers are confirmed by a variety of sources, among them Shalkop 1977, by way of personal correspondence with the artist's daughter. Shalkop notes that Gies was the director of the school, and Paulus, a landscape painter.

16. Laut 1900.

17. Barker 1940, 6. This impetus, which I have not seen cited elsewhere, is somewhat suspect, as Laut's adventure novel of the fur trade, Indian fighting, and the like takes place entirely in Canada, primarily in the Saskatchewan area, and never

mentions Alaska. The ascription of its influence on Ziegler's decision to go north is lent some credence, however, by the fact that it features an adventurous priest on the frontier. Ziegler may well have ignored its Canadian prairies setting and determined that to have such adventures in his own day, he would need to go farther afield, perhaps to Alaska.

18. Jenkins 1943, 53-54.

19. Wilson, "Eustace Paul Ziegler— Alaskan Painter," 380.

20. Ziegler, "John Bunyan, Jr. and Red Dragon Tales," 5-7.

21. Ibid., 5.

22. *Episcopal Church in America, Domestic and Foreign Missionary Society, Alaska Papers 1889-1939.* M/F #142, reel 29.

23. This and other information on early Cordova summarized here are drawn primarily from Nielsen's *The Red Dragon and St. George's: Glimpses into Cordova's Past* and *From Fish and Copper: Cordova's Heritage and Buildings*, excellent publications which treat the settlement of Cordova, its heritage and buildings, and the Red Dragon itself, in considerable detail.

24. Nielsen, *The Red Dragon and St. George's: Glimpses into Cordova's Past*, 2.

25. Newton, "The Red Dragon of Cordova," 403.

26. Ibid.

27. "The Red Dragon of Cordova: A New Type of Mission in the Alaskan Wilds," 14.

28. Newton, "Summer Work on Prince William Sound," 7.

29. "The Red Dragon of Cordova: A New Type of Mission in the Alaskan Wilds," 14.

30. Ibid.

31. Rowe made Ziegler's letter available to *The Alaskan Churchman,* which published it in August 1910 under the heading, "An Interesting Trip."

32. Wilson, "Eustace Paul Ziegler— Alaskan Painter," 380.

33. The photograph is now in the private collection of Candace Waugaman in Fairbanks, Alaska. Ziegler added his own note on its back, "Bill Truscott and I on top of Mt. Eyak. 1909. Cordova Alaska. Photo taken for Colliers by Carlysle Ellis. "

34. "An Interesting Trip," 65.

35. Nielsen, *The Red Dragon and St. George's: Glimpses into Cordova's Past,* 12. According to Nielsen, citing file notes at St. George's Church in Cordova, Winfred remained in Valdez until 1914.

36. Ziegler, "Two Mushers and an Ordination," as excerpted in Nielsen, *The Red Dragon and St. George's: Glimpses into Cordova's Past,* 12.

37. Ziegler, "Missionary's Trip to Bonanza Copper Mine," 11.

38. For more on these strange paintings, including reproductions of them, see Paxton 1986 and *Discovering Art in Packing Boxes, 1969.*

39. "Eustace P. Ziegler: Paintings on Glass," 1987.

40. Ziegler, *Christ at Emmaus,* reproduced in *The Alaskan Churchman,* January 1948, 19. My date of 1905 comes from Ziegler's note "painted 1905," on a copy of the *Alaskan Churchman* page once in his possession, now in the Candace Waugaman collection, Fairbanks, Alaska.

41. This image, too, was reproduced years later in *The Alaskan Churchman,* April 1922, 41.

42. Stuck 1920, 150; Nielsen, *The Red Dragon and St. George's: Glimpses into Cordova's Past,* 16-17.

43. "Dedicate Episcopal Church Tomorrow," 1919.

44. Stuck 1920, 150.

45. "The Alaskan Churchman Scriptorium, the Red Dragon, Cordova," 1922, 70.

46. The St. Martin's Abbey painting is reproduced in color and Ziegler is briefly profiled in the catalog of an exhibition of work in the Martin of Tours Collection organized in 1986 by the Tacoma Art Museum. (Lovell 1986)

47. For a thorough discussion of the life and work of Laurence, as well as his legacy for Alaskan art, see Woodward, *Sydney Laurence, Painter of the North; Painting in the North: Alaskan Art in the Collection of the Anchorage Museum of History and Art;* and *A Sense of Wonder.*

48. Interview with Eustace Paul Ziegler by unidentified persons in Seattle on April 2, 1967.

49. "$5000 Painting by Noted Artist to Be Exhibited by Local Museum," 1940.

50. For a reproduction of Laurence's *Cordova Bay,* see Woodward, *Sydney Laurence, Painter of the North,* 42-43.

51. If, as Ziegler contends in the 1967 interview, he was never jealous of other artists but was always competitive with them, he may have found his already strong predilections away from landscape fortuitous. I do not think, given what we know about him, that he would have shied away from direct competition with Laurence if their interests had been more nearly identical. But given the fact that Ziegler was still young and still in the process of finding his own personal style, the prospect of competing on the exact same ground with the older, much more experienced Laurence would have to have been daunting.

52. Atwood and De Armond 1977, 9.

53. Nielsen, *The Red Dragon and St. George's: Glimpses into Cordova's Past,* 14.

54. Carlson 1971, 2.

55. Shalkop 1977, 4.

56. Harrington 1937, 251. Berkeley Divinity School later moved to New Haven, relocating to the Yale University campus (Glen Wilcox, interview by Phyllis D. Movius).

57. Medley 1924, 90.

58. Nielsen, *The Red Dragon and St. George's: Glimpses into Cordova's Past,* 15.

59. *Episcopal Church in America, Domestic and Foreign Missionary Society. Alaska Papers, 1889-1939.* M/F #142, reel 29. 19 August 1920. All correspondence referred to during the year at Yale is located on reels 29 and 30 of this source.

60. Ziegler, Editorial Introduction, *Alaskan Churchman,* 1922, 5.

61. McIntosh 1932.

62. Episcopal Church in America. Correspondence. M/F # 142, reel 29.

63. Ibid., 13 October 1924.

64. Ibid., 5 July 1924.

65. McIntosh 1932, Carlson 1971, 2, and numerous other sources.

66. Carlson 1971, 3.

67. Shalkop 1977, 4.

68. Falk 1985, 705.

69. Guenther, 87-88.

70. Salmagundi Club 1951.

71. Kollar 1992.

72. For more on Lambert, the 1936 trip, and his relationship with Ziegler, see Woodward, *Painting in the North: Alaskan Art in the Collection of the Anchorage Museum of History and Art,* 83-86.

73. Cumming 1984, 21.

74. Cumming 1984, 229-231.

75. For an extended discussion of changing depictions of Alaska Natives in art during this era, see Woodward, *A Sense of Wonder,* 7-9.

76. Though they are undated, I feel certain that virtually all the brightly colored, impressionistic paintings featured in this exhibition date from a confined period shortly after Ziegler's move to Seattle. I imagine that in the flush of excitement over exposure to artists doing more daring work, he moved in a similar direction. It is less clear why he stopped, returning to naturalistic color, but it may have been lack of interest in more abstract color and handling for its own sake, lack of positive response from his clientele, or both.

77. See, for instance, De Armond 1978, 165, which reproduces a well-known Ziegler image of a Native Alaskan drawn from a Lomen Bros. photograph taken in Nome.

78. Wilson, *Copper-Tints, a Book of Cordova Sketches,* 27-29.

79. Jenkins 1943, 110C.

80. See, for instance, Miletich 1960, in which Zieg refers to his "Alaskan Potboilers" and then defines them, in his typically self-denigrating way, as "something that I'm very familiar with painting, and they are very bad."

81. Indeed, the seated mother and child image *Doxie and Basil,* represented in this exhibition by the outstanding example is probably Ziegler's best known image. Instantly recognizable to anyone at all familiar with his work, a version of this image was reproduced and prints sold throughout this country and Europe.

82. Miletich 1960.

83. Heilman 1965.

84. Untitled column on Ziegler, *Alaska Sportsman* (June 1955): 29.

85. "Paintings by Eustace P. Ziegler: In Memoriam," 1969.

86. Photograph of the award presentation. Candace Waugaman collection, Fairbanks, Alaska.

The Seekers and the Sought: Notes on the Pictures of Eustace P. Ziegler

by Estill Curtis Pennington

In no spirit of brag I will say that I have many paintings in Alaska. Alaskans are great lovers of paintings.

Eustace P. Ziegler,
December 23, 1961[1]

By strenuously urging young men to go West, Horace Greeley, the first media mogul of a jingoistic tabloid press, sought to find a frontier escape valve from the building urban tensions caused by labor unrest and ethnic divisions. This "last frontier" was given its definitive cast by the American historian Frederick Jackson Turner at the high tide of American imperialism, and in a setting which represented the ultimate American achievement: the Chicago of the White City Exposition of 1893. Even as the Columbian Exposition emphasized the bigness, grandeur and divinely ordained abundance of America, Turner wrote that the "existence of an area of free land, its continuous recession, and the advance of American settlement westward, explain American development...."[2]

Turner's theory could be given illustrative representation by the paintings of Eustace Paul Ziegler, peopled as they are by those who have made a "return to primitive conditions on a continually advancing frontier line," and whose consequent efforts result in a vigorous "new development for that area." As though adhering to Greeley's admonitions, Turner envisioned this "perennial rebirth, this fluidity of American life, this expansion westward with...its continuous touch with the simplicity of primitive character" stemming from the potent thrust of "dominating male character."

This "male character" is yet another representation of the hunter/gatherer, that rugged individual whom a variety of current writers, notably Robert Bly and Camille Paglia, are attempting to resurrect.[3] A willingness to ponder the male adventurer as an avatar of civiliza-

tion, one of those "rough-and-ready men in groups, glamorized by trial and toughness," who "helped cement the standard for the great American myth of the cowboy," is critical to understanding the substance of the "last frontier" theme in Ziegler's art.

These cowboys (or prospectors or riders on the range) were the products of the American Victorian imagination, the heroes of the Wild West Show and the novels of Owen Wister, Jack London, and Will James. "In Victorian America," writes James Gifford, "power was embedded in patriarchy, and males were expected to be the embodiment of that power."[4] Leading the kind of strenuous life personified by Teddy Roosevelt, for whom one of Ziegler's artistic contemporaries was named, was "in effect the cultural summation of an aggressive imperialistic movement that had been growing

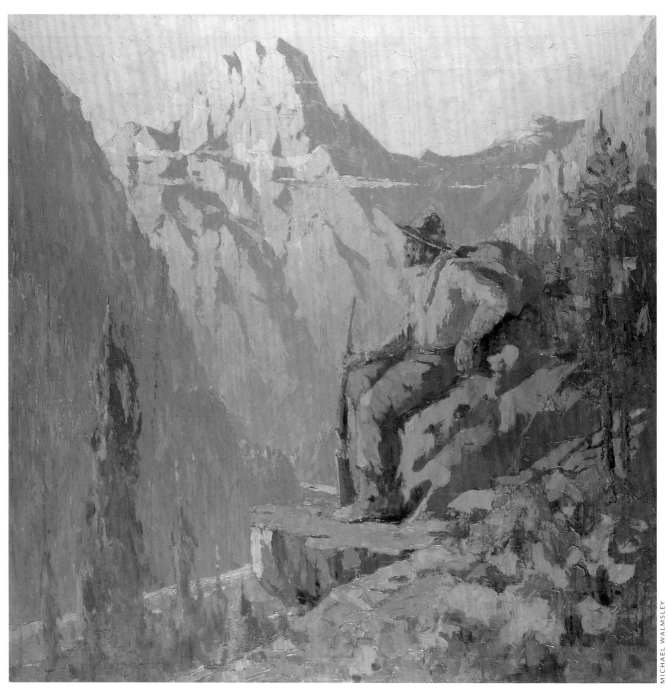

MICHAEL WALMSLEY

The Sourdough
Oil on canvas, 34 x 34 inches

throughout the late nineteenth century."

Passionate, conflicting ideas about those men linger in American culture, feeding a nostalgia for a form of freedom which borders on an anarchic state of being, alone in a wilderness republic devoid of big government and corporate consolidation. If that America had ever existed, it vanished long before Ziegler started to paint, inspiring a longing for an Alaskan "last frontier." As Robert Hughes points out, "by the end of the 1870's, it was abundantly clear that the key to American social reality was no longer the frontier but the cities, whose culture was based on fast change, harsh inequality, the friction of crowds competing in a narrow social space, industry and the impersonal power of the machine."[5]

That reality may have resulted in the gigan-

tic prosperity of the industrial northeast and the farm rich mid-west, but it did not lodge in the popular imagination of a culture in love with the manly seeker. Hughes sees it this way: "People rarely want social reality. They want dreams. As the wilderness and the West declined into objects of nostalgia, emblems of imperiled freedom, they drained out of high art and into popular culture. They became the power house of stereotyped fantasy, whose messages were replicated through Wild West shows, memoirs, illustrations, and novels."

As Paglia asserts, the heroic search commenced by the high-risk-taking male has provided much of the gist of art if not of progressive social history. That distinction is a deliberate one. What we see in paintings is not what social historians may wish to see for the betterment of the interactive human condition, but it is evidence of a cultural anthropology which establishes the riveting centrifugal presence of the hero of a thousand faces.

The most disturbing implication of the last frontier theory is the aura of existential aimlessness which often colors the effort. It may be possible to see the quest for the last frontier as a rather bad melodrama acted out by men unable to cease seeking. These kinds of men are familiar in popular American culture. From Natty Bumpo, to Captain Ahab, to Daniel Boone, to Shane, they ride, or sink, into the sunset.

However, existential crisis does not exist in the cosmos of Ziegler's art. At first viewing we can be struck by the lonely and often pensive quality of his seekers. At the same time, the harsh gesturings of his assayers speak of a cruel, materialistic world. Lest we be tempted to see Ziegler's paintings as illuminations of the existential search for meaning where there is little to be found, we should remind ourselves of Ziegler's very origins. He went to Alaska, after all, as an Anglican missionary, was subsequently ordained as a priest in the Episcopal Church, and kept faith to the tenets of the Christian religion all his life.

Enlightening the Anglican community is the God of the *Book of Common Prayer* "to whom all hearts are open, all desires are made known, and from whom no secrets are hid." This God is both approachable and forgiving, for "you are gracious, oh lover of souls." Ziegler's faith was robust, kindly and pragmat-

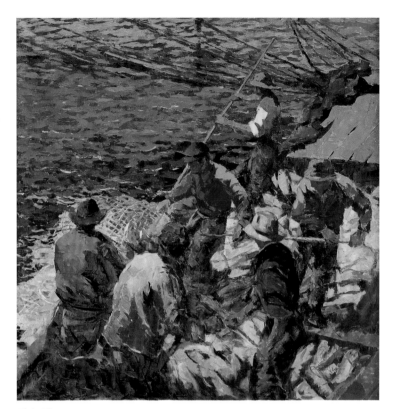

Fish Pirates
Oil on canvas, 34 x 34 inches

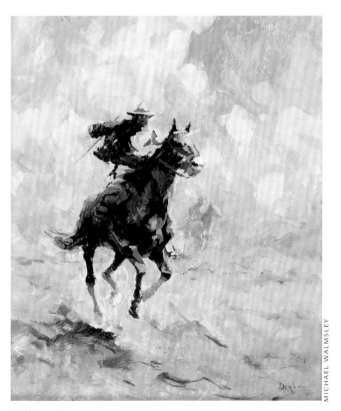

Hell Bent
Oil on board, 12 x 10 inches

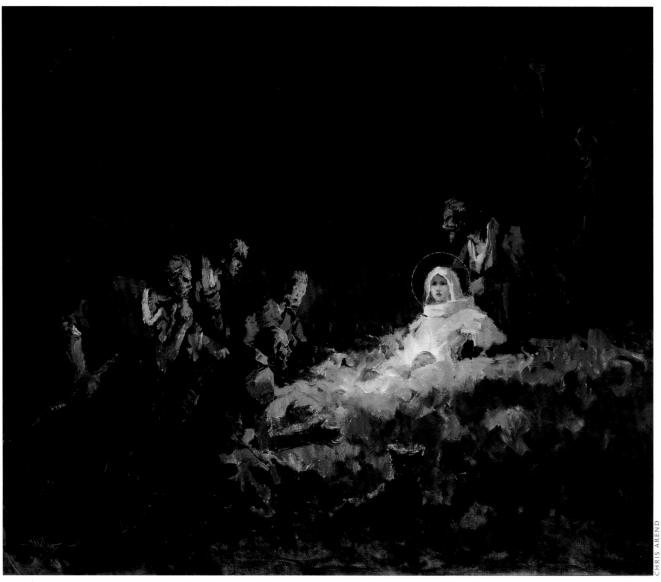

CHRIS AREND

Untitled–Nativity
Oil on canvas, 34 x 40 inches

ic. His work in the Red Dragon mission involved finding alternative forms of entertainment, such as billiards, to divert the frontiersmen from more debilitating activity. [6]

By his activities, Ziegler the missionary sought to nurture and sustain the energies of the men whom Ziegler the painter summoned to the picture plane. As pendants, his native women with their children are thinly veiled allusions to the Madonna, while his literal depictions of Biblical episodes in Alaskan settings extend the symbolic meaning of the territory into a promised land of plenty.

At his best, Ziegler was a master of compositional technique, organizing the planar space into formal layers directing the movement of his figures from foreground to rear ground with considerable ease. His work also evinces a highly personal color sensibility, partially derived from impressionist and tonalist precedents, which rather wondrously conveys the striking colors of the Alaskan terrain. At his least interesting Ziegler is highly repetitive, and some of his works are either flatly illustrative views or caricaturist genre scenes, all of which reek of rapid execution for commercial purposes.

From what we know of Ziegler's development as an artist, his initial inclinations were mimetic, ranging from "illustrating clam shells for a scientific publication to copying old mas-

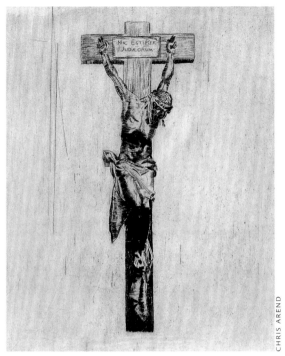

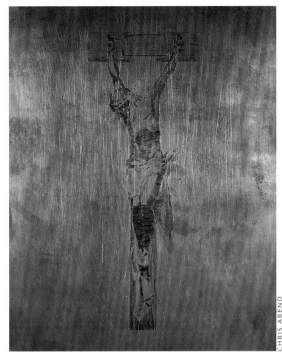

Untitled—Crucifixion
Drypoint, 9 x 7¼ inches

Untitled—Crucifixion
Copper plate, 9 x 8 inches

ters for a local art dealer." That Ziegler was a copier working in a different tradition is documented from the evidence of his work for Episcopal churches in Alaska, including, Robert L. Shalkop notes, a "'Descent from the Cross' to hang over the altar" at St. George's Church, and other "copies of old masters...painted for St. Stephen's Mission at Fort Yukon."[7]

It is not unlikely that these exercises, rather like learning to draw from plaster casts, explain his highly organized understanding of the picture plane. Though primary evidence of his interests, and the emergence of his aesthetics, is scant, a letter written late in his life expressing gratitude for the gift of a group of prints, speaks of "my greatest favorites...Chardin...Luini and Sodoma."[8] Though an unlikely gathering, each of these artists created highly structured works in which the symbolic elements of the content were set within a highly formal composition whose figurative modeling was enhanced by strong color value.

Ziegler had a clear grasp of perspective, both atmospheric and vanishing. That he was capable of achieving figurative arrangement on a very large scale is evident in one of the versions of *The Gold Seekers* which survives, in a restored state, in the collection of the Baranof Hotel in Juneau. Before us, all activity and interest is moving away from the frontality of the picture plane towards a distant mountain range. In the foreground the massive bulk of the loaded boat captures initial visual attention.

As the eye moves further into the image the resolution of the figures becomes dimmer, and the light and shadings of atmosphere become softer and more transparent. This suggestive conjunction of the weight of the effort contrasted with the dim prospects on a distant horizon achieves a marvelous effect, profoundly enhancing Ziegler's theme of seeking and finding.

The paintings of fishermen are equally successful at combining a highly formal compositional technique with a subtle coloration and paint application. In works like *Beach Seiners* and *Sorting Nets*, perspective is foreshortened, deflecting attention from the mystical presence of a distant horizon to the more immediate work at hand. The flattened groupings parallel to the picture plane are confrontational, solid, and more strongly colored than those in the atmospheric works. In this manner Ziegler achieves a naturalistic depiction of an activity much beloved by European artists of the Barbizon, Brittany, Normany, and Hague Schools, artists

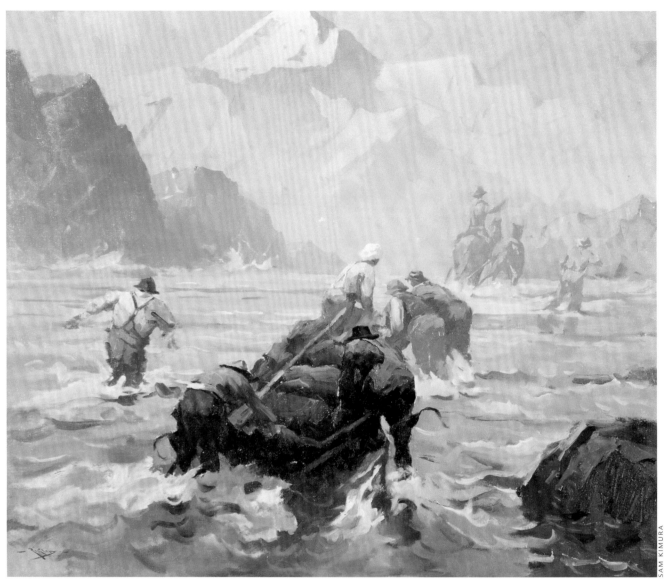

The Gold Seekers
Oil on canvas, 34 x 40 inches

whose works were still current in Ziegler's formative era, and which struck a chord with the attitudes of muscular Christianity.[9]

In his research on Ziegler, Kesler Woodward has uncovered photographs which chronicle Ziegler's sources. Like the work illustrated in a newsletter from the Columbia River Maritime Museum, they "offer mute testimony to activities and structures of days gone by."[10] From this external evidence, and from the internal evidence that Ziegler worked on a canvas lined into a grid to which he transferred an extant composition, we again confront the reality of Ziegler's mimetic tendencies.

From a critical standpoint it is uncertain what we are to make of that fact. In our age, working *en plein air*, or even in a posed studio setting, is considered more truly "artistic" than mimetic appropriation. E. H. Gombrich considered disregard for the mimetic impulse arose from "art history('s)...obsession with space... according to which we 'see' a flat field but 'construct' a tactile space...." By moving beyond the formalist, art historical concern with the organization of the planar space, he believed that we could "bring other achievements into focus, the suggestion of light and of texture, for instance, or the master of physiognomic expression."[11] Appreciation of Ziegler's art springs from a visual awareness of his metaphoric sense of

place, uniquely communicated by his painterly style, occasionally set in mimetic compositions.

In the atmospheric landscapes peopled by the seekers and fishers, there is a vigorous application of paint. Ziegler's preference for the palette knife gives his paintings a heavily impastoed quality and a surface value which enhances his color sensibility to achieve the appropriate mood. This is a "rough" terrain, and a "rough" job, an inference sustained by the tactile quality of the picture surface, energetically rendered.

Robert L. Shalkop's opinion that Ziegler was "an excellent draftsman, but not interested in the use of color for its own sake" falls short of a true understanding of one of Ziegler's greatest achievements as a visual artist.[12] Clearly Ziegler was not a modernist, concerned with the interaction of fields of color slashed with expressionistic brushwork. Yet his sense of color value and harmonic conjunction is one of his best achievements. Ziegler's lesser works have the simple coloration of illustrations. In his more serious effort, color becomes the most important vehicle for conveying the profound, yet indifferent Alaskan landscape, too vast for human domination, ever alluring.

Themes of loneliness, isolation, searching for fortune, and the powers and the mysteries of a distant terrain are emotively conveyed by his use of close color harmonics enlivened by spontaneous positioning of clear color. Ziegler seems to have an almost Whistlerian understanding of the moods to be achieved from juxtapositions of blues and greens in compliment. As blue and green are contiguous on the color spectrum, their increase and diminution are impossible to distinguish clearly, prompting a visual illusion of movement, often experienced as a shimmering light, or a highly tactile, recessional field. [13]

With this technique, Ziegler parted company from the "old masters" he seemingly admired. Within the renaissance canon, the primary colors red/yellow/blue were used to distinguish form and suggest modeling, contouring and volumetric mass. It is this color sensibility, above all else, that heightens the sense of space and proportion in his works and adds an unnerving subliminal sense of action and motion.

Still, Ziegler's more repetitive works cannot be ignored. Success creates its own demands, and apparently to survive as a working artist,

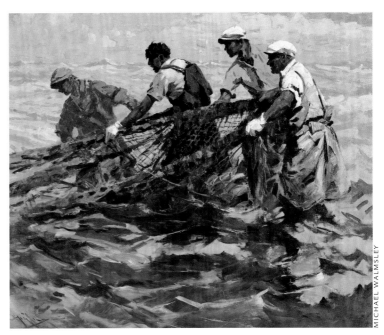

Beach Seiners
Oil on canvas, 34 x 40 inches

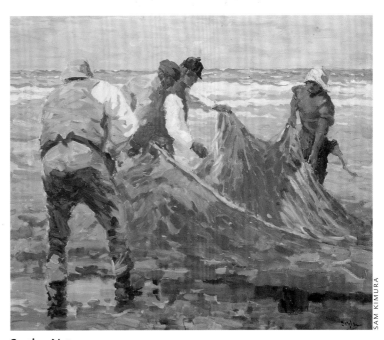

Sorting Nets
Oil on board, 22 x 26 inches

Untitled–Pack train near Mt. McKinley
Oil on canvas, 48 x 114 inches

Ziegler constantly returned, especially in his later life, to familiar compositions. Any review of the artist's oeuvre will inevitably produce quantities of paintings of riders on horseback in green or blue settings, as well as other familiar "Alaska" subjects. As Shalkop states, in "later years he was forced by popular demand to draw upon...early images, and he was engagingly frank about such canvases, referring to them as 'my Alaska potboilers.'" [14] Critically, it would be best to consider these works as a continuation of popular culture imagery, illustrations of

the literary sensibility discussed earlier, redolent of the longing for the heroic individual on the so-called "last frontier."

Critical literature on Ziegler is quite sparse. Early in his career Katherine Wilson, writing for the *American Magazine of Art*, notes that a "series of strikingly colorful murals depicts for the stranger the magnitudes and beauties of the Alaskan landscape." Though an echo of Victorian piety, her response to his art affirms the success of his technique to communicate his metaphoric appreciation for place. "Upon a

CHRIS AREND

technique zealously cultivated under great disadvantages at an outpost of civilization," the missionary/artist/frontiersman "brings to bear a buoyant and sensitive spirit and a consciousness enriched by his own stirring and profound experiences." [15]

Clearly, the totemic power of heroic males seeking their fortune on the last frontier remained one of the most evocative themes in Ziegler's depictions of an exotic locale. His success in communicating the themes of his *inhabited* landscapes may best be gauged by comparisons with Sydney Laurence, one of the "old masters" of Alaskan painting. [16]

What Laurence brought to Alaskan art was the well-honed style of the New English Art Club and the Newlyn School of coastal Cornwall. The emotive glow which he casts upon his innumerable images of Mt. McKinley combine the warmly sensitive, indeed comforting palette of English impressionism with an (unconscious?) reference to the American luminist movement of the mid-nineteenth century. Laurence's best work is highly dra-

BRIAN ALLEN

Untitled–Packhorses
Oil on canvas, 23 x 28 inches

matic, capturing the scale and power of the Alaskan scene. Laurence creates beautiful self-fulfilling prophecies, largely devoid of human activity, and reminiscent of nascent cinemagraphic technique, the god-head on the mountain top thundering down upon the placid meadows. [17]

Ziegler, on the other hand, brings a far more fledgling, febrile, quality to his effort. While Laurence was an artist in his maturity, setting out for Alaska in a vaguely fugitive manner, Ziegler was fresh, and his initial impressions of the terrain served him well. By combining thematic elements drawn from the challenge of human endeavor set against the ambiguity of an incredibly beautiful, incredibly dangerous terrain, Ziegler depicts both setting and endeavor in the Alaskan pageant.

Determining the significance of Ziegler's creations in the context of Alaskan art history requires both a sensitivity to his depictions and a disinclination to accept hierarchical placements of American artists. Each artist func-

tioning in America deserves consideration based on that combination of technique and sensibility which we have been exploring. Paintings provide a deceptive bit of evidence, a persistent image of actions and emotions most often conjured up by the means of language, either as history, poetry or fiction. The picture, Malcolm Budd writes, "is both lesser and greater than the corresponding face-to-face experience in ways that profoundly affect the beholder's interest in what he sees and his delight in the experience." [18] Lesser, in lacking the third dimension of human reality, but greater as an enduring object.

Eustace Paul Ziegler sought to capture the spirit of the seekers, dwarfed by their vast blue-green paradise, solitary but content with their search, and secure in their belief that prosperity and redemption would be obtained on the frontier borders of a promised land. Regardless of the outcome or implications of *their* search, that is what *he* found.

Notes

I am most grateful to Kesler Woodward for the kind and generous guidance he offered on this project, a collaboration among Morris Communications Corporation, the Morris Museum of Art and the Anchorage Museum of Art and History. This essay is dedicated to my wonderful assistant Betty Parker, always helpful, always patient and kind. —ECP.

1. Eustace Ziegler to Aaron Ginsberg, 23 December 1961, ALS, Morris Communications Corporation Art Archives.
2. All quoted passages taken from Frederick Jackson Turner, *The Frontier in American History* (New York: H. Holt and Company, 1921). For further information on the Chicago World's Fair, see David F. Burg, *Chicago's White City of 1893* (Lexington, Kentucky, 1976).
3. See Robert Bly, *Iron John* (Reading, Mass.: Addison-Wesley, 1990) and Camille Paglia, *Sexual Personae* (New Haven: Yale University Press, 1990).
4. James Gifford, *Dayneford's Library: American Homosexual Writing*, 1900-1913 (Amherst: University of Massachusetts Press, 1995).
5. Robert Hughes, *American Visions* (New York: Alfred A. Knopf, 1997): 201, 202.
6. For a comparative discussion of the importance of "muscular" Christianity in nineteenth-century colonialism, see James Morris, *Pax Brittanica* (New York: Harcourt Brace Jovanovich; London: Faber, 1968).
7. Robert L. Shalkop, *Eustace Ziegler: A Retrospective Exhibition* (Anchorage; Anchorage Historical and Fine Arts Museum, 1977): 4.
8. Eustace Ziegler to Aaron Ginsberg, December 24, 1962, ALS, Morris Communications Corporation Art Archives.
9. Peter Bermingham, *American Art in the Barbizon Mood* (Washington: Published for the National Collection of Fine Arts by the Smithsonian Institution Press, 1975).
10. "When Skinners and Hookers Waded the Tide," *The Quarterdeck* (Astoria, Oregon) 20, no. 1 (fall-winter 1993): unpaged.
11. E. H. Gombrich, *Art and Illusion* (Princeton, New Jersey: Princeton University Press, 1969): 331.
12. Shalkop. 5
13. See Rudolf Arnheim, *Art and Visual Perception* (Berkeley: University of California Press, 1954).
14. Shalkop. 6
15. Katherine Wilson, "Eustace Paul Ziegler—Alaskan Painter," *Magazine of American Art* (July 1925): 381.
16. For the definitive discussion on Sydney Laurence, see Kesler E. Woodward, *Sydney Laurence, Painter of the North* (Seattle: University of Washington Press in association with the Anchorage Museum of History and Art, 1990).
17. For a discussion of proto-cinematic comparisons, see Anne Hollander, *Moving Pictures* (Cambridge, Mass.: Harvard University Press, 1991).
18. Malcolm Budd, *Values of Art*, (London, England: Penquin Books, 1996): 82.

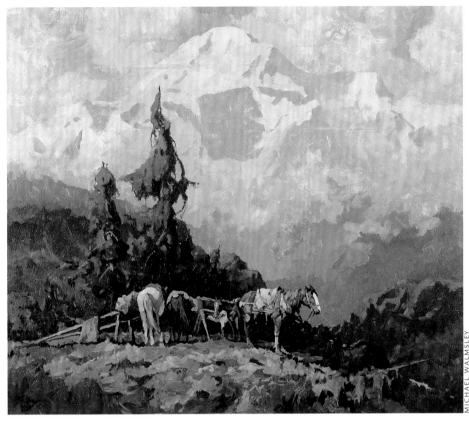

MICHAEL WALMSLEY

Mt. McKinley and Packhorses
Oil on board, 34 x 40 inches

Eustace P. Ziegler:
Additional Works

PHOTOGRAPH BY DAVE POTTS; CANDACE WAUGAMAN COLLECTION

Eustace Paul Ziegler at 87, January 7, 1969

Character Studies

Woodsman
Oil on canvas, 8 x 10 inches

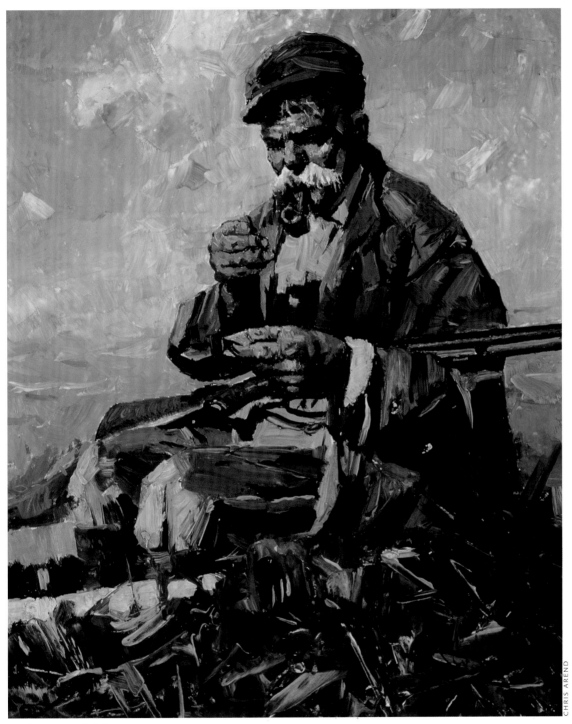

Duck Hunter Lighting Up
Oil on board, 7 x 6 inches

CHRIS AREND

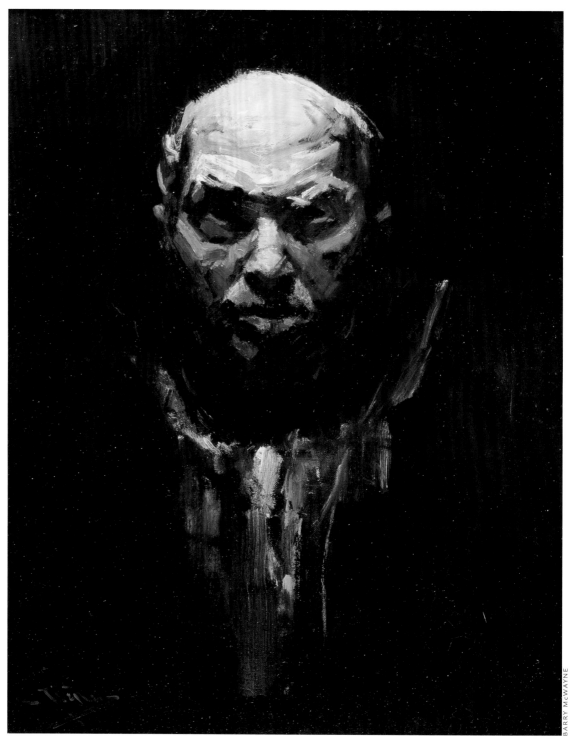

Old Hard Rock
Oil on canvasboard, 20 x 16 inches

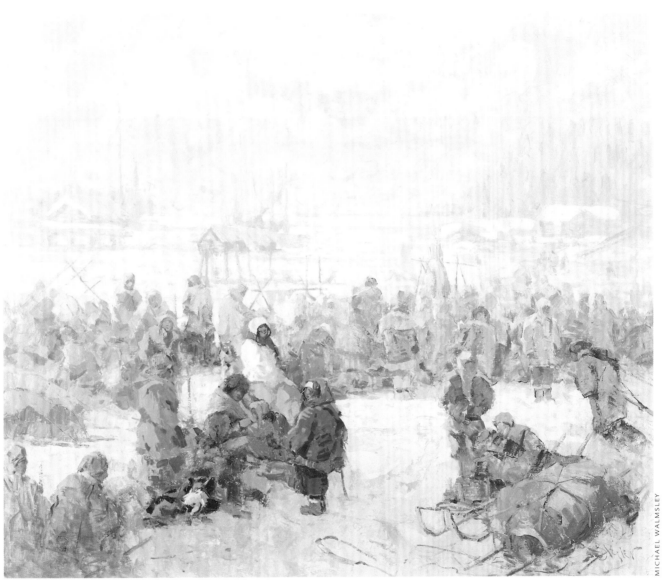

MICHAEL WALMSLEY

Indian Camp
Oil on canvas, 40 x 48 inches

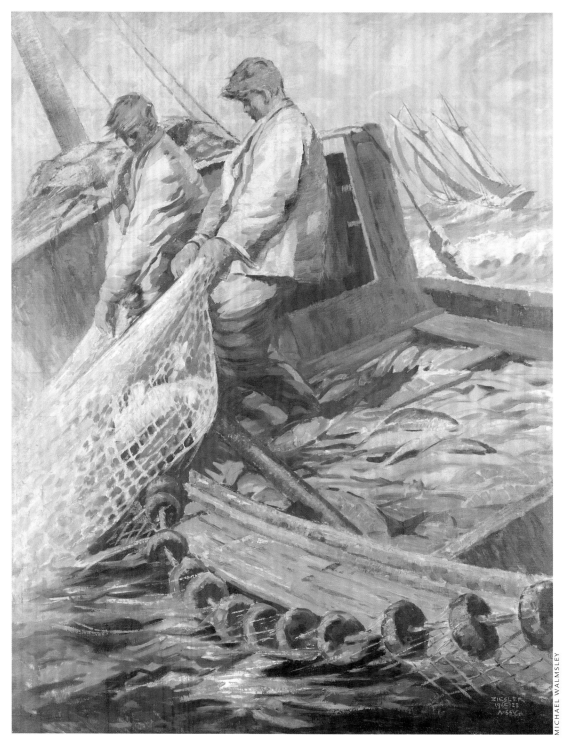

Pullin' in the Catch
Oil on canvas, 65½ x 50¾ inches

MICHAEL WALMSLEY

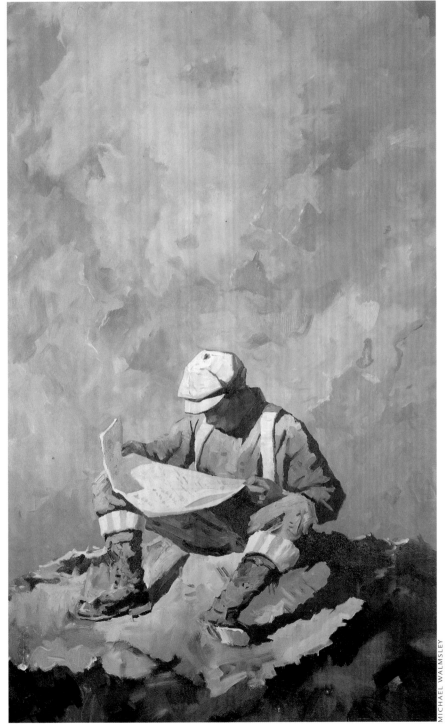

Untitled-Man sitting on mountaintop, reading a newspaper
Oil on canvas, 72 x 48 inches (approx.)

Formal Portraits

'Cap' Lathrop
Oil on canvas, 40 x 32 inches

BARRY McWAYNE

Dr. Charles E. Bunnell
Oil on canvas, 40 x 34 inches

Impressionistic Paintings

Chief Shakes' Cabin
Oil on board, 9¹/₂ x 11¹/₄ inches

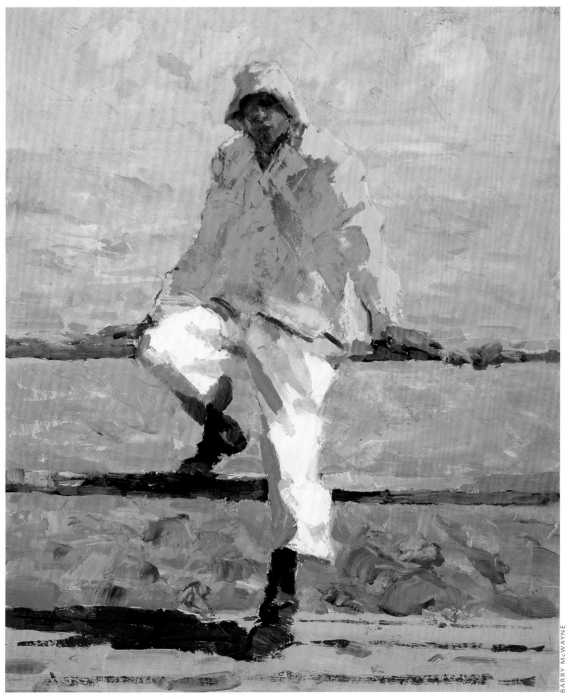

Untitled-Man in yellow raincoat
Oil on canvas, 11½ x 9½ inches

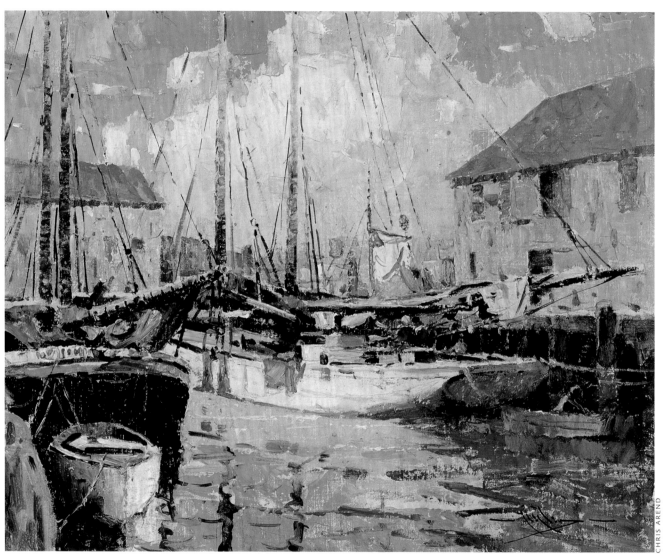

In Port
Oil on canvasboard, 16 x 20 inches

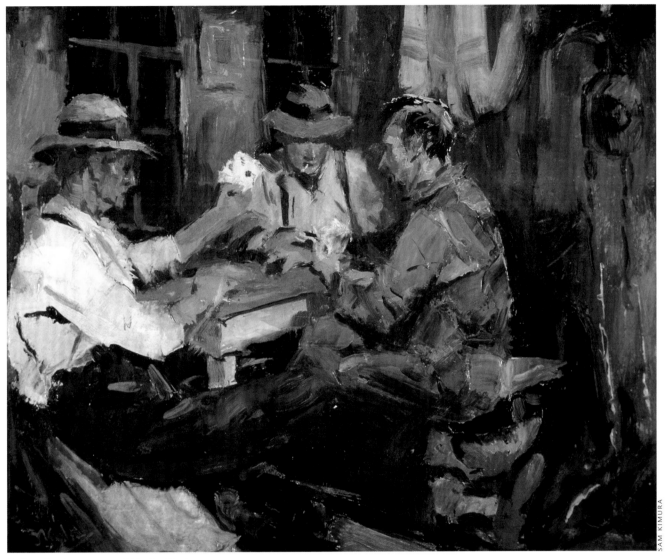

Doing the Assessment Work, Alaska
Oil on canvasboard, 8 x 10 inches

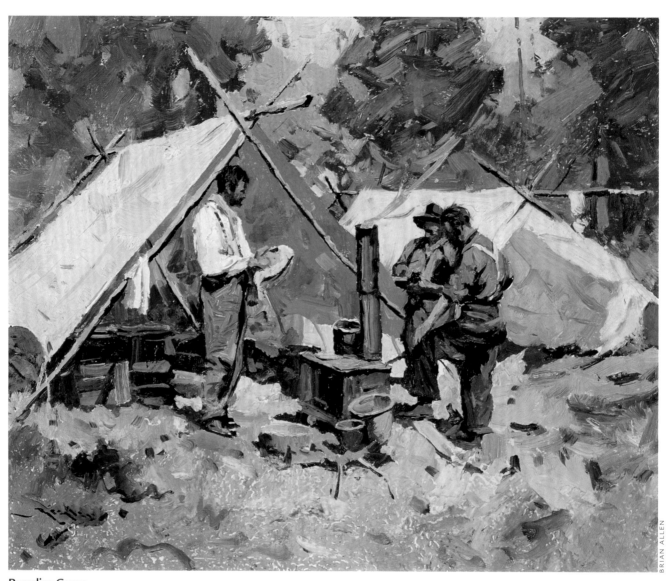

BRIAN ALLEN

Paradise Camp
Oil on canvas, 15 x 17 inches

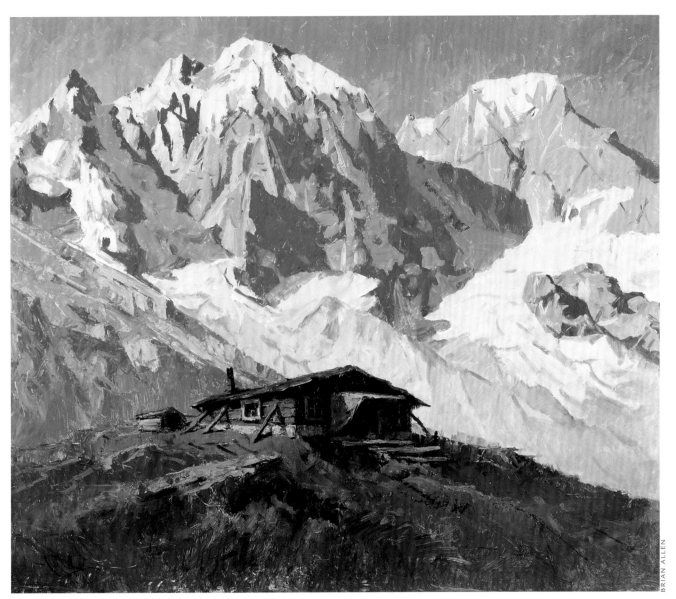

Untitled-Cabin on mountaintop
Oil on board, 34 x 40 inches

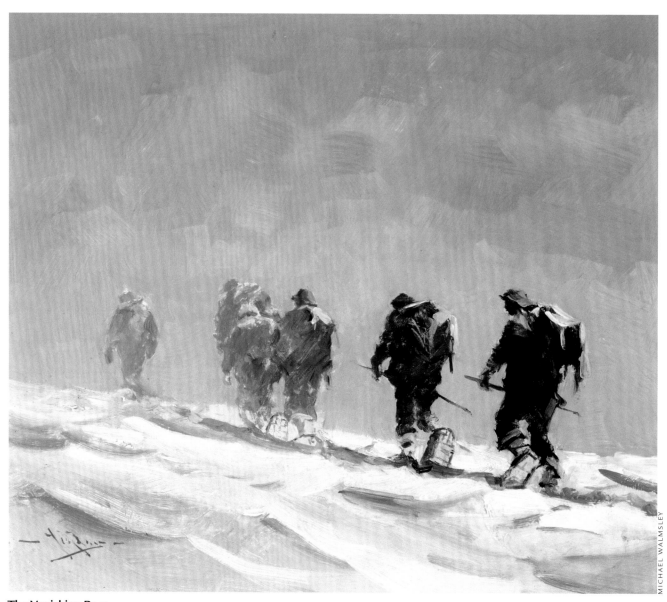

The Vanishing Race
Oil on board, 12 x 14 inches

Untitled-Miners, one with Giant
Pencil drawing, 7½ x 5 inches

MICHAEL WALMSLEY

Untitled-Miners, one with Giant
etching, 7¹/₂ x 4³/₄ inches

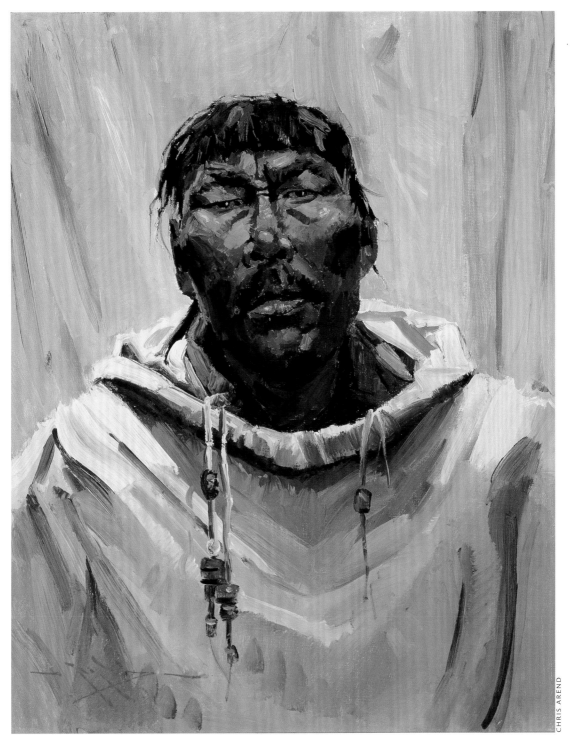

CHRIS AREND

Untitled-Eskimo man
Oil on canvasboard, 20 x 16 inches

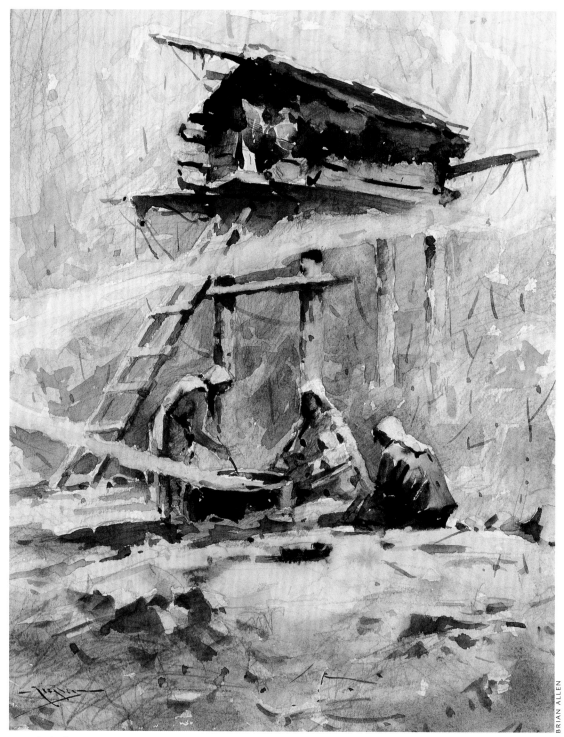

BRIAN ALLEN

Untitled-Three native women with campfire and cache
Watercolor, 15 x 11 inches

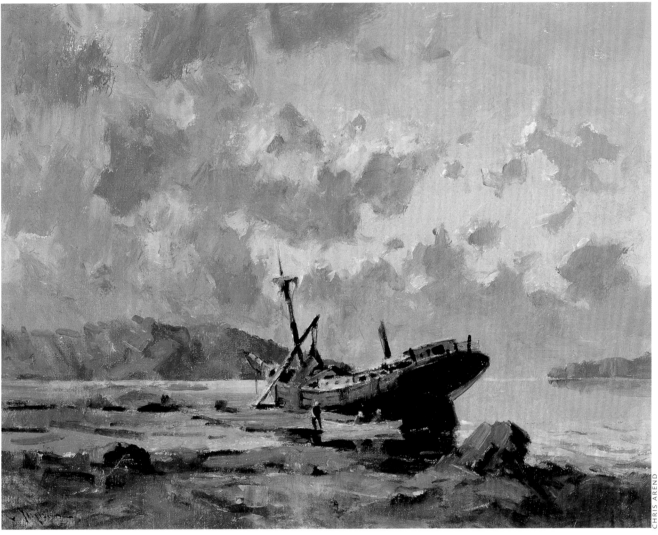

The Derelict
Oil on canvasboard, 16 x 20 inches

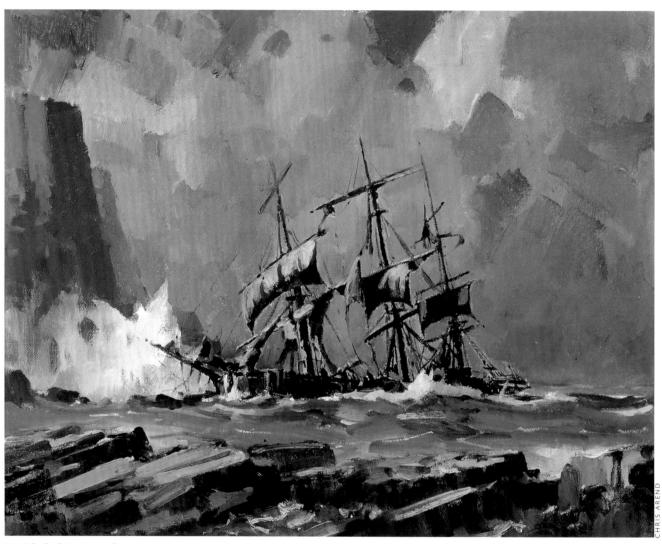

CHRIS AREND

Untitled-Ship in surf
Oil on canvas, 16 x 20 inches

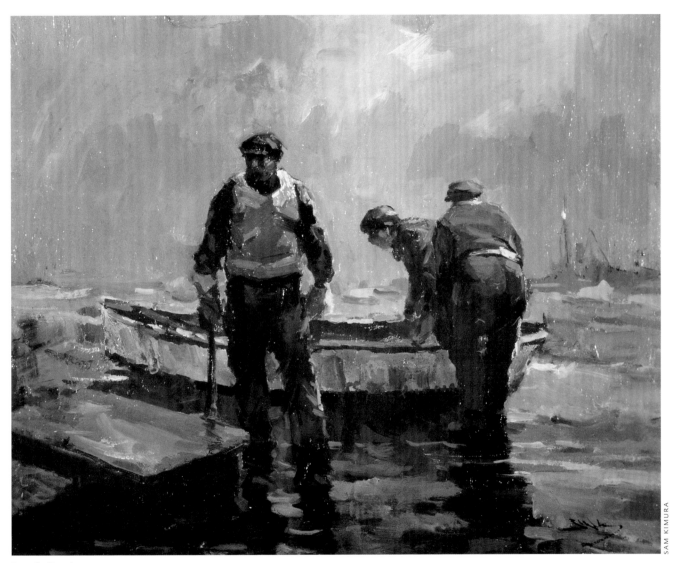

Beach Combers
Oil on board, 16 x 20 inches

SAM KIMURA

Untitled-Sailing ship
Oil on canvas, 32 x 28 inches

Untitled-Shipwreck
Oil on canvasboard, 16 x 20 inches

In Tow

Oil on board, 10 x 12 inches

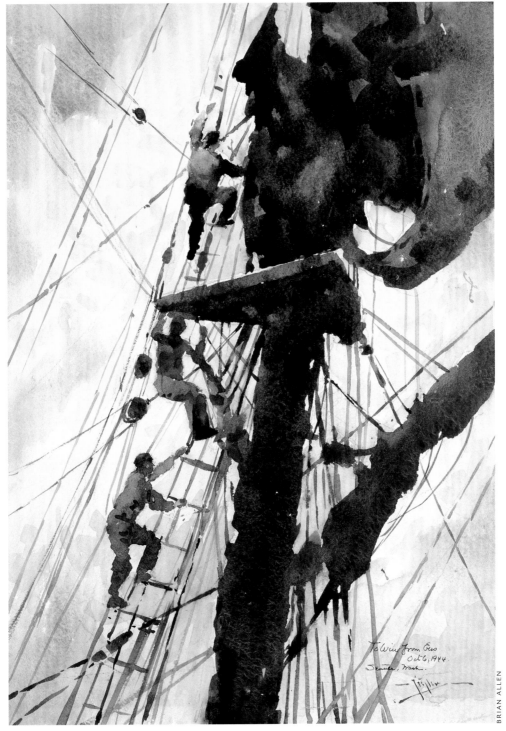

On the Ratlines, 1944
Watercolor, 15 x 11 inches

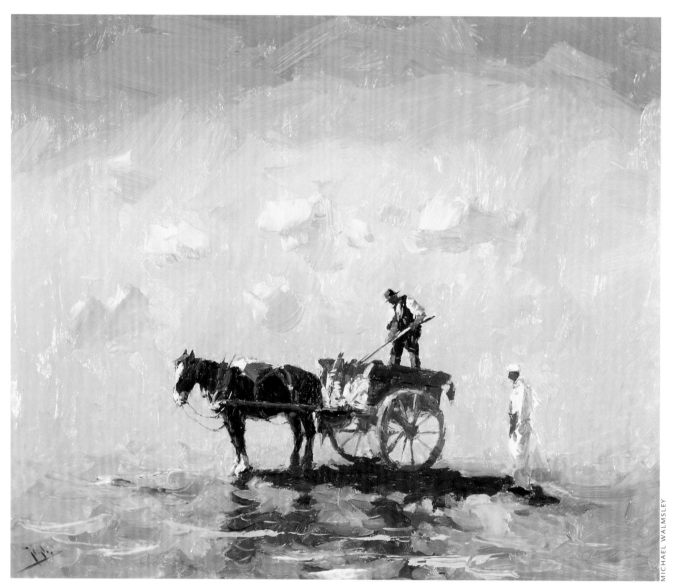

MICHAEL WALMSLEY

The Kelp Gatherers
Oil on board, 10 x 12 inches

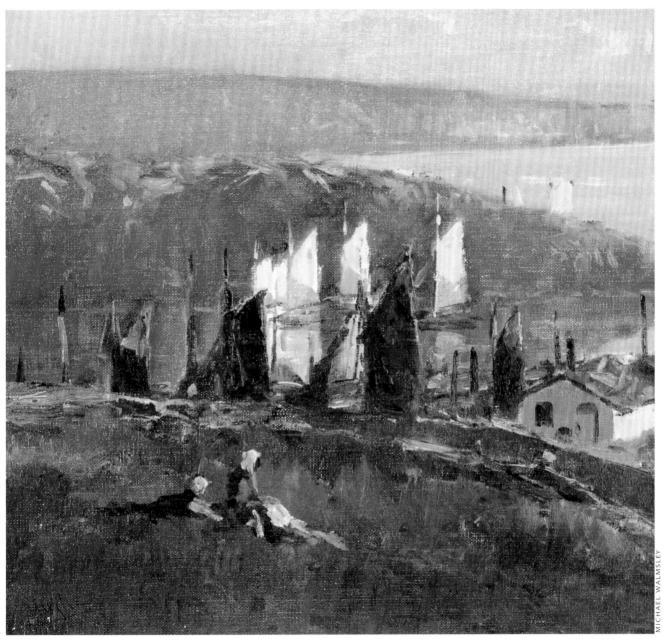

Untitled-Halibut Schooners
Oil on canvasboard, 17 ¼ x 18 ¼ inches

MICHAEL WALMSLEY

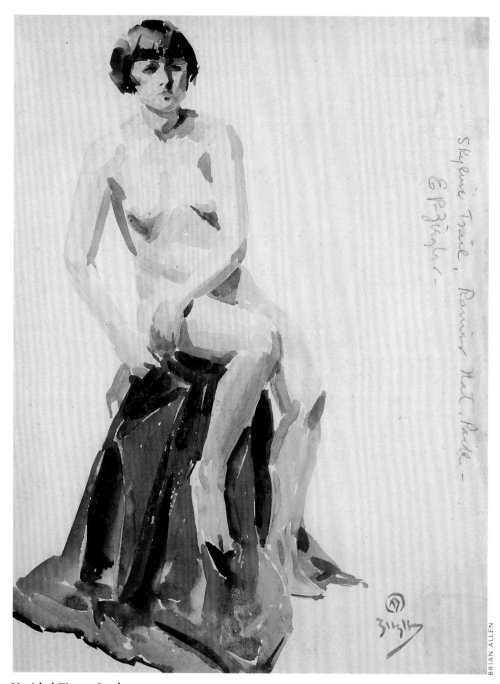

BRIAN ALLEN

Untitled-Figure Study
Watercolor, 12½ x 9 inches
verso of **Skyline Trail—Mt. Rainier National Park**

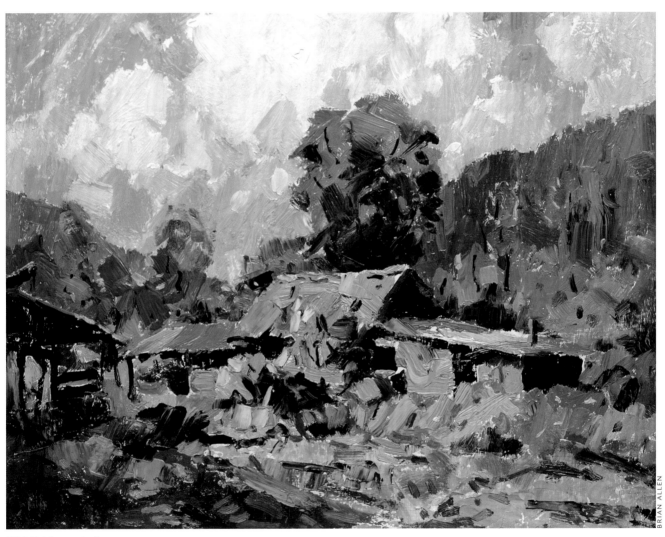

Old Cabins at Index
Oil on board, 11 x 14 inches

1936 Trip down Yukon and Kuskokwim Rivers

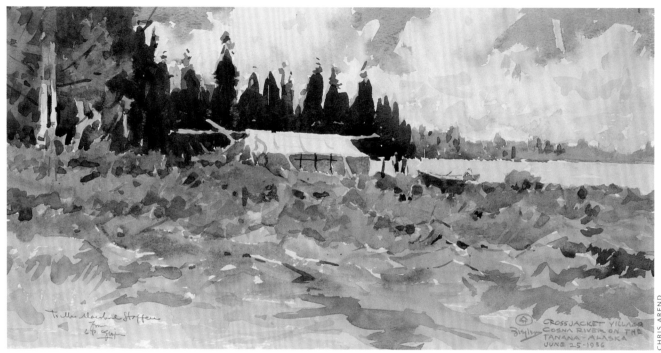

Cross Jacket Village, Cosna River on the Tanana, Alaska, June 25, 1936
Watercolor, 7 x 13 inches

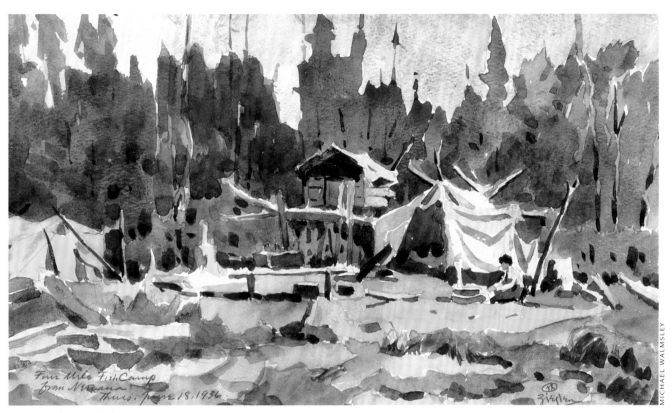

Four Mile Fish Camp
from Nenana
Thurs. June 18, 1936.

Nenana River Fish Camp
Watercolor, 7¼ x 12¼ inches

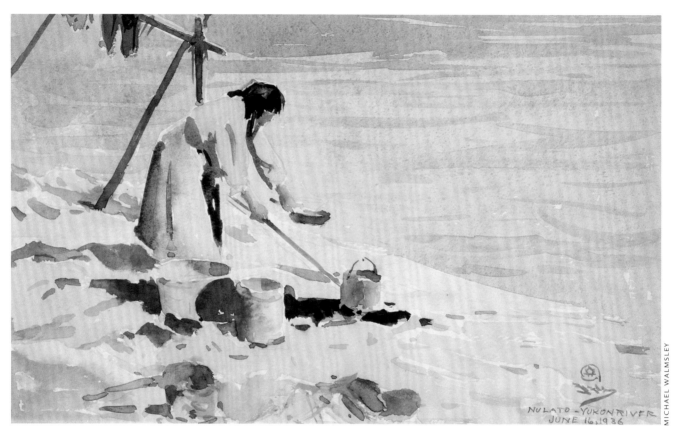

Nulato-Yukon River, June 16, 1936

Watercolor, 7 x 11½ inches

Jim McHugh's Cabin-Grant Creek, Yukon River, Alaska, July 2, 1936
Watercolor, 7 x 13¼ inches

Hot Springs Slough-Tanana River, Alaska, Tuesday, June 23, 1936
Watercolor, 7 x 11¹/₂ inches

SPIRIT OF THE NORTH

Betty Anne at the Summit of the Yukon-Kuskokwim Portage—August 10, 1936
Watercolor, 7 x 12 inches

Ten Miles below Nenana on the Tanana—June 17, '36
Watercolor, 7 x 14 inches

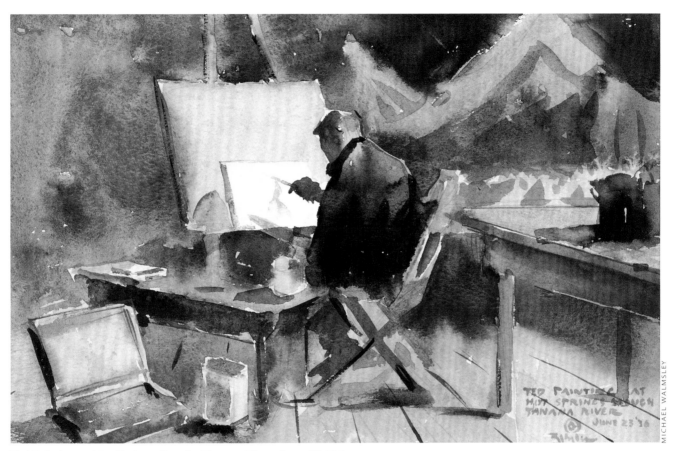

Ted Painting at Hot Springs Slough—Tanana River—June 23, '36
Watercolor, 7 x 11 inches

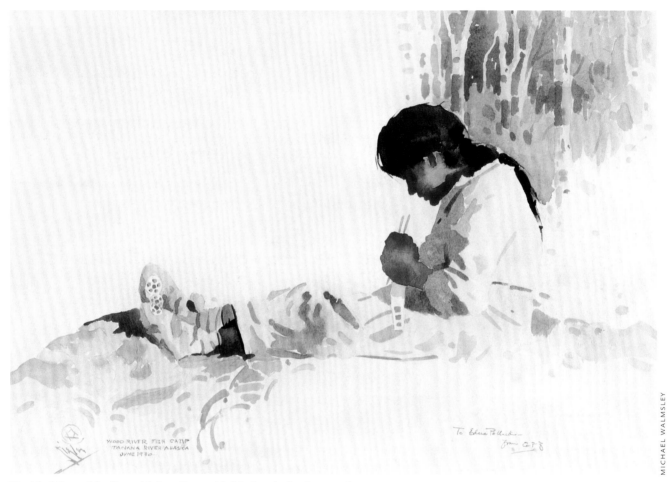

Untitled-Seated Indian girl, beading, with birches in background
Watercolor , 11 x 15 inches

MICHAEL WALMSLEY

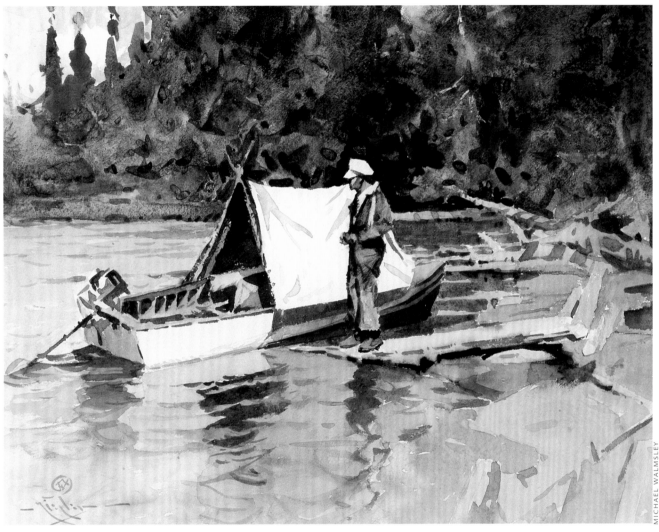

Ted on the Yukon, 1950s
Watercolor, 12 x 15 inches

Untitled-Jim Fitzgerald painting at Index, 1940
Oil on canvasboard, 10 x 12 inches

Bootleggers Cove
Oil on canvasboard, 10 x 12 inches

CHRIS AREND

Untitled-Fly Fishing
Watercolor, 8¹⁄₂ x 12¹⁄₂ inches

A New Star is Born
Oil on canvasboard, 20 x 16 inches

DAVID GELOTTE

Arch Cape, Oregon
Oil on board, 11½ x 13½ inches

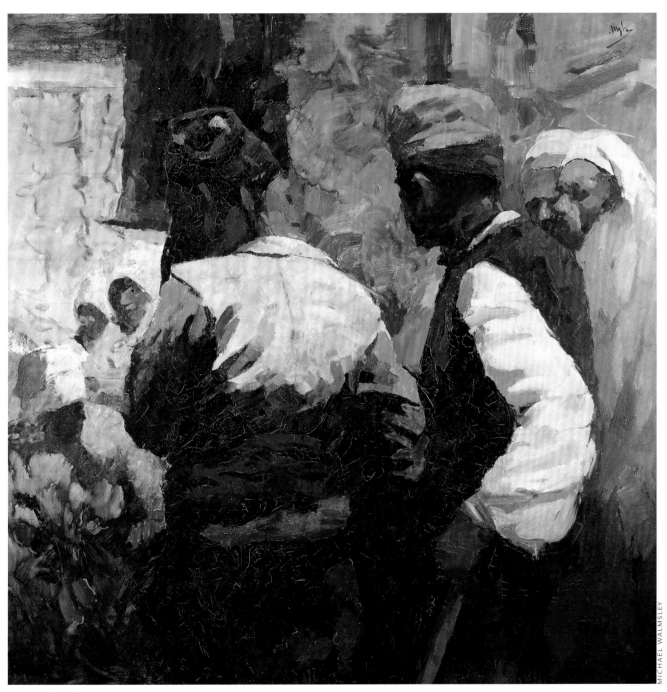

MICHAEL WALMSLEY

Dawn of Doubt
Oil on canvas, 34 x 34 inches

Illustrated letter to Jack Gilbert
Watercolor, 10 x 14 inches

Untitled-Newspaper Office
Oil on canvas, 12 x 28 inches

MICHAEL WALMSLEY

Untitled-Chinatown
Watercolor, 13 x 9 ¹/₂ inches

Eustace P. Ziegler:
A Selected Bibliography

Kesler Woodward

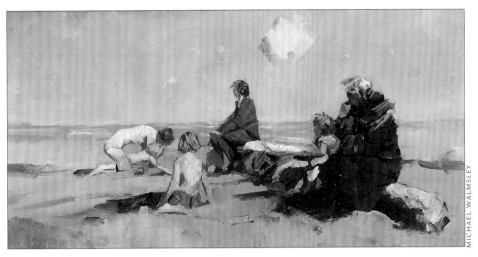

The Family at Alki
oil on panel, 8¼ x 15¾ inches

"The Alaskan Churchman Scriptorium, the Red Dragon, Cordova." *Alaskan Churchman* (April 1922): 70.

"Alaskan Wing Opening." *Frye Vues* (February 1984).

"The American Artists Professional League." *Art Digest* (15 May 1937): 32.

"Art Exhibit in Tacoma." *Seattle Post-Intelligencer*, 11 February 1968.

Atwood, Evangeline, and Robert N. De Armond. *Who's Who in Alaskan Politics*. Portland: Inford and Mort, 1977.

Batie, Jean. "Ziegler Exhibition at Frye." *Seattle Times*, 2 February 1969, D8.

Barker, Charles. "Philosopher on Canvas." *Alaskan Life* (May 1940): 6, 30.

Becker, Nan. Correspondence with Anchorage Museum Director Robert L. Shalkop. Eustace P. Ziegler File, Anchorage Museum of History and Art.

Blaubelt, Lea. "The Northwest Report: Noted Seattle Artist Eustace Ziegler Died January 28, a Few Days after His Big Show Was Hung in the Frye Art Museum." *Westart* (21 February 1969): 3.

Bonnell, Raymond. "An Artist on the Trail: Edmond James FitzGerald and the U.S. Geological Survey." *Alaska Journal* 16 (1986): 55-60.

Cahan, Ann Z. Correspondence with Anchorage Museum Director Robert Shalkop. Eustace P. Ziegler File, Anchorage Museum of History and Art.

Callahan, Margaret B. "Ziegler, An Artist Who Eats Regularly." *Seattle Times* (4 May 1947).

Carlson, Phyllis D. "Alaska's Hall of Fame Painter: A Sourdough Painter-Preacher." *Alaskana* (November 1971): 1-3.

Cumming, William. *Sketchbook: A Memoir of the 1930s and the Northwest School.* Seattle: University of Washington Press, 1984.

De Armond, Robert N. "Ziegler in Black and White." *Alaska Journal* 8, no. 2 (spring 1978): 162-169.

"Dedicate Episcopal Church Tomorrow." *Cordova Daily Times,* 19 April 1919.

"Discovering Art in Packing Boxes." *Seattle Times,* 29 June 1969, 18.

Editorials/Business. *Seattle Post-Intelligencer,* 1979, Section B.

Eicher, Edith. "Truly a Northwest Artist." *Town Crier* (December 1934): 34.

Episcopal Church in America, Domestic and Foreign Missionary Society. Alaska Papers, 1889-1939. (microfilm (M/F #142, reels 29, 30), Archives, Alaska and Polar Regions Department, Elmer E. Rasmuson Library, University of Alaska Fairbanks).

"Eustace P. Ziegler." *Great Lander* (Anchorage, Alaska), 3 December 1980, 1, 6.

"Eustace P. Ziegler, Noted Northwest Artist." Obituary. *Seattle Post-Intelligencer,* 28 January 1969.

"Eustace P. Ziegler: Paintings on Glass." *Frye Vues* (December 1987).

"Eustace P. Ziegler Remembers Cordova." *Cordova Daily Times,* 18 May 1958.

"Eustace P. Ziegler: Special Memorial Exhibition." *Frye Vues* (February 1972).

"Eustace Paul Ziegler Is Exhibiting a Small Painting at the Seattle Art Museum." *Town Crier* (July 1937): 10.

"A Eustace Ziegler Masterpiece Has Returned to Alaska." *Anchorage Daily News,* 3 November 1972, 6.

Falk, Peter Hastings, ed. *Who Was Who in American Art.* Madison, Connecticut: Sound View Press, 1985.

"$5000 Painting by Noted Artist to Be Exhibited by Local Museum." *Bellingham Herald,* 24 November 1940.

"Forty-five Paintings by Eustace Ziegler— Frye Art Museum." *Westart* (7 February 1969): 5.

Frye Art Museum. *Three Alaskan Artists: Ted Lambert, Sydney Laurence, Eustace Ziegler.* Exhibition flyer. Seattle: Frye Art Museum, 1978.

"Frye Shows Alaska Scenes." *Seattle Post-Intelligencer,* 21 January 1972, 3.

Gilbert, Kenneth. *Alaskan Poker Stories: Stories by Kenneth Gilbert.* Illustrations by Eustace Ziegler. Seattle: Robert D. Seal, 1958.

Godden, Jean. "We Say Thanks for the Memories, Old P-I Building." *Seattle Post-Intelligencer,* 14 August 1985, C1.

Grinnell, May. "Cordova." *Alaska-Yukon Magazine* 8 (August 1909): 326-331.

Guenther, Bruce. "Guy Anderson." *Guy Anderson.* Exhibition Catalog. Seattle: Francine Seders Gallery, 1986.

Haley, Delphine. "Eustace Ziegler Echoed the Call of the Wild." *Seattle Post-Intelligencer*, 30 January 1972: 12.

Harrington, Rebie. *Cinderella Takes a Holiday in the Northland*. New York: Fleming H. Revell Company, 1937.

Heilman, Robert. "Artist Treasures 'Studio' Key." *Seattle Times*, 28 January 1965.

Hoffman, Fergus. "The Active Life of Eustace Ziegler." *Seattle Post-Intelligencer*, 19 January 1969, Northwest Today section, 10-13.

—"Artist Calls Self Hack, Sells Product Easily." *Seattle Post-Intelligencer*, 6 June 1956.

—"Eustace Ziegler, Noted Seattle Artist, Succumbs." *Seattle Post-Intelligencer*, 28 January 1969.

—"Zig Doesn't Sag as Popular Artist." *Seattle Post-Intelligencer*, 26 February 1967, 18.

"An Interesting Trip." *Alaskan Churchman (August 1910): 65.*

"Honorable Mention." *Pathfinder of Alaska* (July 1922): 13.

Jenkins, Thomas. *The Man of Alaska: Peter Trimble Rowe*. New York: Morehouse-Gorham Co., 1943.

Kollar, Allan J. *Edmond James FitzGerald N.A., A.W.S., American 1912-1989*. Seattle: Kollar and Davidson Gallery, 1992.

Kosmos, George. *Alaska Sourdough Stories: Stories by George Kosmos*. Illustrations by Eustace Ziegler. Seattle: Robert D. Seal and George R. West, 1956.

Laut, Agnes C. *Lords of the North*. Toronto: William Briggs, 1900.

Lovell, Charles M., ed. *Martin of Tours Collection: The Art of St. Martin's Abbey*. Exhibition catalog. Tacoma, Washington: Tacoma Art Museum, 1986.

McIntosh, Mary. "'Zieg' Famous Art Circles of Northwest." *Cordova Daily Times*, 14 May 1932.

Medley, Edward F. "The Little Minister." *Alaskan Churchman* (October 1924): 90-94.

Midnight Sun Broadcasting Company. *KFAR Keybook of Interior Alaska: From the Top of the World to You*. Illustrations by Eustace Ziegler and Ted Lambert. Fairbanks, Alaska, and Seattle: Midnight Sun Broadcasting Company, 1939.

Miletich, Matt. "He Digs Gold with a Paintbrush." *Seattle Times*, 31 January 1960.

Missionary District of Alaska. "Notice of Deposition [of Eustace P. Ziegler]." (22 May 1937).

"Museum Gets New Paintings." *Nanook News*, 29 January 1971, 2. "News Note." *Alaska Life* (August 1939): 9.

Newton, E. P. "Prospecting for the Church in Southern Alaska." *Spirit of Missions* (August 1909): 701-702.

— "The Red Dragon of Cordova." *Alaska-Yukon Magazine* (December 1910): 403-404.

— "Summer Work on Prince William Sound." *Alaskan Churchman* (November 1908): 7.

Nielsen, Nicki J. "Eustace Ziegler." *Alaska Geographic: The Copper Trail* 16, no. 4 (1989): 46-47.

—*From Fish and Copper: Cordova's Heritage and Buildings*. Alaska Historical Commission Studies in History, no. 124. Cordova: Cordova Historical Society, 1984.

—*The Red Dragon and St. George's: Glimpses into Cordova's Past*. Cordova: Fathom Publishing Company, 1983.

"Notes." *Alaskan Churchman* (January 1922): 34.

"Painters Exhibiting Their Work at Frederick and Nelson's Are Men: Edgar Forkner, Eustace Paul Ziegler, Paul Gustin, Ernest Norling, Erik Johnson, Arne Jensen, William Klamin and Glen Shekels," *Town Crier* (June 1935): 30.

"Paintings by Eustace P. Ziegler." *Frye Vues* (February 1969).

"Paintings by Eustace P. Ziegler: In Memoriam." *Frye Vues* (March 1969).

Paxton, Gene. "Ziegler on Glass: Window Paintings from Eustace Ziegler's Cabin in Cordova." *Alaska Journal* 16 (1986): 70-71.

Pennington, Estill Curtis. *Frontier Sublime: Alaskan Art from the Juneau Empire Collection*. Augusta, Georgia: Morris Museum of Art, 1997.

Phillips, Carol, ed. *A Century of Faith*. Fairbanks, Alaska: Centennial Press, 1995.

"The Red Dragon of Cordova: A New Type of Mission in the Alaskan Wilds." <u>Colliers</u> (24 June 1911): 14.

Salmagundi Club. Correspondence with Ziegler. Notice of election to Non-Resident Associate Artist membership. 2 February 1951.

"Services Set for Eustace Ziegler." Obituary. *Seattle Times*, 27 January 1969, 41.

Shalkop, Robert L. *Eustace Ziegler: A Retrospective Exhibition*. Exhibition catalog. Anchorage: Anchorage Historical and Fine Arts Museum, 1977.

"Special Edition Hailing Alaska Appears in Wednesday's P-I: Symbolic Painting for Special Edition." *Seattle Post-Intelligencer*, 27 October 1958.

Stuck, Hudson. *The Alaska Missions of the Episcopal Church*. New York: Domestic and Foreign Missionary Society, 1920.

"Three Alaskan Artists." *Frye Vues* (March 1978).

Tower, Elizabeth A. "Eustace Paul Ziegler—Alaska's Other Painter." *Alaska History News* 21, no. 4 (fall 1990): 4.

Untitled column on Eustace Ziegler. Includes photo of Ziegler and one of his paintings. *Alaska Sportsman* (June 1955): 29.

Wilcox, Glen. Interview by Phyllis D. Movius. 11 December 1996.

Wilson, Katherine. "Eustace Paul Ziegler—Alaskan Painter." *American Magazine of Art* (July 1925): 377-381.

—*Copper-Tints, a Book of Cordova Sketches*. Cordova: Cordova Daily Times Press, 1923.

Woodward, Kesler E. *Painting in the North: Alaskan Art in the Collection of the Anchorage Museum of History and Art*. Alaska: Anchorage Museum of History and Art, 1993.

—*A Sense of Wonder*. Fairbanks, Alaska: University of Alaska Museum, 1995.

— *Sydney Laurence, Painter of the North.* *Seattle*: University of Washington Press in association with Anchorage Museum of History and Art, 1990.

"Ziegler Back in Alaska; Will Have Exhibit Here." *Fairbanks News-Miner*, 11 August 1952, 5.

"Ziegler Collection." *Frye Vues* (January 1991).

Ziegler, Eustace Paul. Editorial Introduction. *Alaskan Churchman* (January 1922): 5-8.

— *Christ at Emmaus.* Reproduction. *Alaskan Churchman* (January 1948): 19.

— *Eskimo Boys on the Banks of the Yukon.* Reproduction. Art Digest (1 November 1940): 40.

— Handwritten letter to *Seattle Post-Intelligencer.* 4 March 1967.

— Handwritten notes on Nordale Hotel (Fairbanks) stationery, n.d.

— Interview by unidentified persons in Seattle, 2 April 1967. Phonotape C-7. Alaska State Library.

— "He Wanted a Squaw." Illustrated with etching by Ziegler. *Town Crier* (July 1937): 10.

— "John Bunyan, Jr. and Red Dragon Tales." *Alaskan Churchman* (January 1924): 5-7.

— "Missionary's Trip to Bonanza Copper Mine." *Alaskan Churchman* (November 1910): 11-13.

— "A Trip to the Silver Salmon Fishermen." *Spirit of Missions* (May 1913): 317-319.

— "Two Mushers and an Ordination." *Spirit of Missions* (June 1912): 452.

Checklist of the Exhibition

Character Studies

Woodsman
Oil on canvas, 8 x 10 inches
Private collection

Duck Hunter Lighting Up
Oil on board, 7 x 6 inches
May Louise Nock

Old Hard Rock
Oil on canvasboard, 20 x 16 inches
University of Alaska Museum, UA81-1-1
Gift of Guilbert G. Thompson

Commissioned work

Untitled—Loggers sitting on a log in the woods
Oil on canvas, 54 x 54 inches
Seattle Post-Intelligencer

Indian Camp
Oil on canvas, 40 x 48 inches
Robert J. Behnke

Alaskan Summer
Oil on canvas, 24 x 20 inches
Nancy Skinner Nordhoff

The Sourdough
Oil on canvas, 34 x 34 inches
Skinner Corporation

Pullin' in the Catch
Oil on canvas, 65 $^{1}/_{2}$ x 50 $^{3}/_{4}$ inches
Skinner Corporation

The Monks
Oil on board, 20 x 16 inches
University of Washington Campus Art Collection
Seattle, WA

The Presses
Oil on board, 20 x 16 inches
University of Washington Campus Art Collection
Seattle, WA

The Radio
Oil on board, 20 x 16 inches
University of Washington Campus Art Collection
Seattle, WA

**Untitled—Man sitting on mountaintop,
reading a newspaper**
Oil on canvas, 72 x 48 inches (approx.)
University of Washington Campus Art Collection
Seattle, WA

Early Cordova

Russian Priest
Watercolor, 9 x 7 $^{1}/_{2}$ inches
Anchorage Museum of History and Art, 75.13.1
Gift of the Rasmuson Foundation

Untitled—To Arch from Eus, 1910
Watercolor and gouache
21 $^{1}/_{2}$ x 14 $^{3}/_{4}$ inches
Anchorage Museum of History and Art, 83.118.1
Municipal Acquisition Fund purchase

Horse Creek Mary
Oil on canvas, 34 x 24 inches
Anchorage Museum of History and Art, 96.15.1
Gift of Harold E. and Trudy Stack

St. Joseph's [Catholic] Church, Cordova
Oil on Masonite®, 34 x 39 $^{3}/_{4}$ inches
Mr. Hugh S. Ferguson

Cordova Native, 1918
Watercolor, 9 $^{1}/_{4}$ x 8 inches
University of Alaska Museum, UA75-35-1

Untitled—House with mountains in background
Inscribed: Ziegler, Valdez, Alaska 1912
Watercolor, 4 $^{1}/_{4}$ x 6 $^{1}/_{2}$ inches
Richard and Irene Cook

Untitled—Barn, fence, mountains
Inscribed: Ziegler, Valdez, Alaska 1912
Watercolor, 5 x 7 $^{1}/_{2}$ inches
Richard and Irene Cook

Formal Portraits

'Cap' Lathrop
Oil on canvas, 40 x 32 inches
Anchorage Museum of History and Art, 91.83.1,
Gift of Elsie Hill

Dr. Charles E. Bunnell
Oil on canvas, 40 x 34 inches
University of Alaska Museum, UA74-70-1
*Gift of the Alumni Association and the Associated Students
of the University of Alaska*

Impressionistic paintings

Chief Shakes' Cabin
Oil on board, 9¹/₂ x 11¹/₄ inches
University of Alaska Museum, UA85-11-2
Gift of Alice T. Witt

Untitled—Man in yellow raincoat
Oil on canvas, 11¹/₂ x 9¹/₂ inches
University of Alaska Museum, UA76-8-78
Gift of Gerald FitzGerald

In Port
Oil on canvasboard, 16 x 20 inches
Anchorage Museum of History and Art, 70.171.4
Gift of Dr. Howard Romig

Sorting Nets
Oil on board, 22 x 26 inches
Alaska State Museum, VA - 285

Miners and Copper River Country

The Gold Seekers
Oil on canvas, 34 x 40 inches
Alaska Pacific University

Doing the Assessment Work, Alaska
Oil on canvasboard, 8 x 10 inches
Anchorage Museum of History and Art, 73.98.1
Gift of the Anchorage Museum Association

Untitled—Pack train near Mt. McKinley
Oil on canvas, 48 x 114 inches
Personal collection

Untitled—Keystone Canyon
Oil on canvas, 20 x 16 inches
John and Thelma Bagoy

Paradise Camp
Oil on canvas, 15 x 17 inches
Private collection

Untitled—Packhorses
Oil on canvas, 23 x 28 inches
Private collection

Untitled—Cabin on mountaintop
Oil on board, 34 x 40 inches
Mt. McKinley Mutual Savings Bank, Fairbanks

Reconnaissance
Watercolor, 10¹/₂ x 14³/₄ inches
University of Alaska Museum, UA 70-306-10
Gift of Gerald FitzGerald

Mt. McKinley and Packhorses
Oil on board, 34 x 40 inches
*The Alaskan Art Collection of Morris Communications
Corporation*

The Vanishing Race
Oil on board, 12 x 14 inches
Private collection

Untitled—Miners, one with giant
Pencil drawing, 7¹/₂ x 5 inches
Len and Jo Braarud, LaConner, WA

Untitled—Miners, one with giant
Etching, 7¹/₂ x 4³/₄ inches
Len and Jo Braarud, LaConner, WA

The Fording
Oil on canvas, 34 x 40 inches
Baranof Hotel/Westmark Hotels

Caribou Hunters
Oil on board, 16 x 20 inches
Heritage Library of the National Bank of Alaska

Native Alaskans

Untitled—Eskimo man [frontal portrait]
Oil on canvasboard, 20 x 16 inches
Anchorage Museum of History and Art, 95.75.13
*Gift of Freda M. Hunke of Leawood, Kansas,
in memory of her early life in Alaska*

Untitled—Eskimo man [profile]
Oil on canvas, 20 x 16 inches
Anchorage Museum of History and Art, 95.75.14
*Gift of Freda M. Hunke of Leawood, Kansas,
in memory of her early life in Alaska*

Native (Arctic)
Oil on board, 12 x 10 inches
Anchorage Museum of History and Art, 95.75.18
*Gift of Freda M. Hunke of Leawood, Kansas,
in memory of her early life in Alaska*

Russian Mission, Alaska
Watercolor, 10¹/₂ x 10 inches
Anchorage Museum of History and Art, 97.38.1
Herb and Miriam Hilscher Collection

Eskimo Head, Lower Yukon
Oil on canvas, 20 x 16 inches
Alaska State Museum, VA-286

Untitled—Three native women with campfire and cache
Watercolor, 15 x 11 inches
Private collection

Tanana Woman and Dog
Oil on canvasboard, 20 x 16 inches
University of Alaska Museum, UA91-17-1
Gift of Grace Berg Schaible

Going to the Potlatch
Oil on canvas, 21 x 27 inches
Ann Ghiglione O'Keefe

Doxie and Basil
Oil on canvas, 24 x 36 inches
Harold E. and Trudy Stack

Madonna of the North
Oil on canvas, 40 x 36 inches
George and Linda Suddock

Untitled—Raven Totem
Oil on canvas, 12 x 10 inches
M. Lamont Bean

Pre-Alaska

Untitled—A fashionable young woman, 1903
Oil on canvasboard, 24 x 18 inches
Anchorage Museum of History and Art, 89.15.1
Gift of Len and Jo Braarud, LaConner, WA

Religious pictures

Untitled—Crucifixion
Copper drypoint plate, 9 x 8 inches
Private collection

Untitled—Crucifixion
Drypoint, 9 x 7 1/4 inches
Private collection

Christ on the Way to Emmaus
Oil, grisaille on paintboard, 14 x 12 inches
Private collection

The Raising of the Son of the Widow of Nain
Oil on board, 10 x 17 inches
Private collection

Untitled—Breaking bread at Emmaus
Oil on board, 16 x 20 inches
Private collection

Untitled—Nativity
Oil on canvas, 34 x 40 inches
Private collection

Ships and the Sea

The Derelict
Oil on canvasboard, 16 x 20 inches
Anchorage Museum of History and Art, 91.62.4,
Gift of National Bank of Alaska

Untitled—Ship in surf
Oil on canvas, 16 x 20 inches
The Harry J. Hill Family

Beach Combers
Oil on board, 16 x 20 inches
Anchorage Museum of History and Art, 70.147.3,
Gift of Mr. and Mrs. Robert O. Kinsey

Untitled—Sailing ship
Oil on canvas, 32 x 28 inches
Private collection

Untitled—Shipwreck
Oil on canvasboard, 16 x 20 inches
Mr. Hugh S. Ferguson

In Tow
Oil on board, 10 x 12 inches
May Louise Nock

On the Ratlines, 1944
Inscribed: (lower left) To Win from Eus / Oct. 6, 1944 /
Seattle, Wash
Watercolor, 15 x 11 inches
Private collection

Fish Pirates
Oil on canvas, 34 x 34 inches
Seattle Art Museum, 33.877
Gift of Dr. A.H. Peacock, Edward Calderón

Beach Seiners
Oil on canvas, 34 x 40 inches
*The Alaskan Art Collection of Morris Communications
Corporation*

The Kelp Gatherers
Oil on board, 10 x 12 inches
Private collection

Untitled—Halibut schooners
Oil on canvasboard, 17 1/4 x 18 1/4 inches
Len and Jo Braarud, LaConner, WA

Seattle Area Pictures

Untitled—Canoeing at Skykomish
Watercolor, 10 1/4 x 14 1/2 inches
Alan and Cathy Fulp

Skyline Trail—Mt. Rainier National Park
Watercolor, 9 x 12 1/2 inches
verso: figure study, watercolor, 12 1/2 x 9 inches
Private collection

Old Cabins at Index
Oil on board, 11 x 14 inches
Private collection

Untitled—Three men in woods
Oil on canvasboard, 16 x 16 inches
Private collection

*1936 Trip down Yukon and
Kuskokwim Rivers with Ted Lambert*

Hand-drawn map of 1936 trip
Pen, pencil on brown paper, 16 x 20 inches
Candace Waugaman

**Cross Jacket Village, Cosna River on
the Tanana, Alaska, June 25, 1936**
Watercolor, 7 x 13 inches
Anchorage Museum of History and Art, 75.26.1
Gift of the Anchorage Museum Association
(Actual name of site is Cos Jacket Village)

Nenana River Fish Camp
Watercolor, 7 1/4 x 12 1/4 inches
Stephen M. Agni and Jacqueline Carr-Agni

Nulato—Yukon River, June 16, 1936
Watercolor, 7 x 11 inches
Richard and Irene Cook

Jim McHugh's Cabin—Grant Creek, Yukon River, Alaska,
July 2, 1936
Watercolor, 7 x 13 1/4 inches
Richard and Irene Cook

Hot Springs Slough—Tanana River, Alaska, Tuesday,
June 23, 1936
Watercolor, 7 x 11 1/2 inches
Richard and Irene Cook

A Wet Day on the Yukon, Nulato, Alaska,
1936 by Ted Lambert
Watercolor, 7 1/2 x 11 1/2 inches
Private collection

Betty Anne at the Summit of
the Yukon-Kuskokwim Portage—August 10, 1936
Watercolor, 7 x 12 inches
Ann Ziegler Cahan

Ten Miles below Nenana on the Tanana—June 17, '36
Watercolor, 7 x 14 inches
Ann Ziegler Cahan

Ted Painting at Hot Springs Slough—Tanana River—
June 23, '36
Watercolor, 7 x 11 inches
Ann Ziegler Cahan

Untitled—Seated Indian girl, beading,
with birches in background
Inscribed: Wood River Fish Camp, Tanana River,
Alaska 1930
Watercolor, 11 x 15 inches, framed 18 x 22 inches
Ann Ziegler Cahan

With Other Artists

Zieg Sketching at Index by Jim Fitzgerald
Oil on canvasboard, 9 x 12 inches
Len and Jo Braarud, LaConner, WA

The Camp (Zieg and Ted), ca. 1963
Inscribed: To Fred from Zieg / A very bad picture
I could never sell
Oil on canvasboard, 12 x 14 inches
Private collection

Ted on the Yukon, 1950s
Watercolor, 12 x 15 inches
Commissioned by Ray Muellner, Lewiston, Idaho.
Private collection
(Image of 1936 trip, but done in the 1950s.)

Ted and Zieg
Watercolor, 11 1/2 x 15 inches
Private collection

Untitled—Jim Fitzgerald painting at Index, 1940
Oil on canvasboard, 10 x 12 inches
Len and Jo Braarud, LaConner, WA

Erik Painting, 1933
Oil on canvasboard, 20 x 19 1/2 inches
Len and Jo Braarud, LaConner, WA

Ziegler Family

Untitled—Man and woman on beach in
Laguna Beach, California
Watercolor, 10 x 13 1/2 inches
Private collection

Untitled—Ann Ziegler in high school or college
on porch at the Ziegler home on the street
below Volunteer Park, Seattle.
Oil on canvas, 8 x 10 inches
Ann Ziegler Cahan

Untitled—Conté crayon drawing of Mary Boyle Ziegler
Conté crayon, 31 x 29 inches
Ann Ziegler Cahan

The Family at Alki
Oil on panel, 8 1/4 x 15 3/4 inches
Len and Jo Braarud, LaConner, WA

Miscellaneous

Hell Bent
Oil on board, 12 x 10 inches
Private collection

Bootleggers Cove
Inscribed on reverse: Aug. 26, 1927, Fairbanks
Oil on canvasboard, 10 x 12 inches
Anchorage Museum of History and Art, 97.38.1
Herb and Miriam Hilscher Collection

Untitled—Fly fishing
Watercolor, 8 1/2 x 12 1/2 inches
Heritage Library of the National Bank of Alaska

Mount McKinley with Mining Camp
Oil on canvas, 16 x 20 inches
Heritage Library of the National Bank of Alaska

A New Star is Born
Inscribed on back: Alaska Statehood, Dec. 1959
Oil on canvasboard, 20 x 16 inches
Judge James A. and Verna von der Heydt
(Note: Alaska Statehood was Jan. 3, 1959)

Arch Cape, Oregon
Oil on board, 11 1/2 x 13 1/2 inches
*The Alaskan Art Collection of Morris Communications
Corporation*

Dawn of Doubt
Oil on canvas, 34 x 34 inches
Ann Ziegler Cahan

Illustrated letter to Jack Gilbert
Watercolor, 10 x 14 inches
Harry and Judi Mullikin

Untitled—Newspaper office
Oil on canvas, 12 x 28 inches
*The Alaskan Art Collection of Morris Communications
Corporation*

Untitled—Chinatown
Watercolor, 13 x 9 1/2 inches
Len and Jo Braarud, LaConner, WA

Index of Illustrations